William Hazlitt
on
the elgin marbles

ET REMOTISSIMA PROPE

'on'

'on'
Published by Hesperus Press Limited
4 Rickett Street, London sw6 1ru
www.hesperuspress.com

First published 1816–1824
First published by Hesperus Press Limited, 2008

Foreword © Tom Paulin, 2008

Designed and typeset by Fraser Muggeridge studio
Printed in Jordan by Jordan National Press

ISBN: 1-84391-602-9
ISBN13: 978-1-84391-602-4

on
the elgin marbles

Contents

Foreword

William Hazlitt was born in Maidstone in 1778. His father, William, was an Irish Unitarian minister from Co. Tipperary; his mother, Grace Loftus, was from a Dissenting family in Cambridgeshire. Through his father, Hazlitt would appear to have inherited a combination of Irish and English republicanism. American republicanism, too, for Benjamin Franklin was a friend of the Rev. William Hazlitt.

Hazlitt initially had hopes of becoming a painter, and on leaving the Unitarian academy he attended in London, he studied painting under his brother John's tutelage. Some of their paintings have survived – notably Hazlitt's thoughtful self-portrait – and are on permanent exhibition in the Maidstone City Art Gallery. Hazlitt's portrait of his dear friend and fellow Unitarian, Charles Lamb, can be seen in the National Portrait Gallery. He was also passionately interested in philosophy and in 1804 he published *An Essay on the Principles of Human Action*. The essay fell stillborn from the press and it was only in the late twentieth century that its originality was recognised by professional philosophers in the United States. Hazlitt gave up portrait painting and philosophy to become a parliamentary reporter (he had learnt shorthand at school), then became a drama critic and essayist. He earned a precarious living as a literary journalist until his death from stomach cancer in a Soho lodging house in 1830. Unlike his former friends Wordsworth, Coleridge and Southey, he never changed his principles, once comparing himself to the type of Indian holy man who keeps one arm raised always in the same position.

Hazlitt was the master essayist of his age, and is commonly regarded as one of the greatest masters of English prose style. Though it is hard to find copies of his books in the shops, many are available online and his reputation has been kept alive by selections of his essays, of which many have been published.

In this selection we have seven of his most seminal essays. In 'On the Pleasure of Painting' Hazlitt writes about the physical, sensuous, imaginative exercise of painting as actual embodied practice. He says that painting is not like writing because it demands the 'continued and steady' exercise of muscular power, but reading this and other essays we notice that his style has itself a precisely embodied muscular power, which in his time was defined as 'nervous' and which we might call 'sinewy'. He aims not just to describe the painter walking up and down his studio but to bring into his writing the tactile feel of an art being practised. He is the critic as artist.

This essay concludes with his touching account of painting a portrait of his father in the small, now abandoned Unitarian chapel in Wem, the Shropshire village where Hazlitt grew up. It ends with Hazlitt hearing the news of Napoleon's victory at Austerlitz and seeing 'the evening star set over a poor man's cottage' – an image which embodies the belief that in time Napoleon's victory would lead to greater equality between the classes. Hazlitt worshipped Napoleon right to the end of his life and died happy that a Bourbon king had been overthrown in the July Revolution in Paris in 1830.

He further developed the idea of the delight in nature which the true painter must take in 'The Same Subject Continued'. In it, Hazlitt remembers the three months he spent in the Louvre in 1802, during the peace that followed the Treaty of Amiens. The *'beau jour'* he mentions as he marches through the Louvre echoes and subverts Burke's indignant use of the term in his polemic *Reflections on the Revolution in France*.

'On a Landscape of Nicolas Poussin' has perhaps one of the finest opening paragraphs of an essay ever penned. It places Poussin's blind, semi-naked giant among the green, dewy forests, scenery which in a characteristic run of massy adjectives Hazlitt calls 'full, solid, large, luxuriant'. The opening paragraph ends with a triumphant exclamation, saying that Poussin is 'lord of nature and her powers; and his mind is universal, and

his art the master-art!' Here, we observe and participate in the gusto which Hazlitt defines in his essay on the subject. This is one of his most essential qualities and we can see it in the beautiful paragraph where he discusses Titian's flesh colour, its '*morbidezza*' or softness. Though he praises Raphael, he unerringly suggests in a footnote that Raphael's figures always have 'an *indoor* look', which he defines in another run of definite adjectives as 'set, determined, voluntary, dramatic'. Only a painter, we feel, can give us such a privileged insight into art.

His intense conviction that it is impossible to separate art from nature informs his three essays on the Elgin Marbles. When he talks of the 'play of flexibility of limb and muscle' in the carvings, we again experience the physical stretch of Hazlitt's prose. That Hazlitt is thinking of prose – indeed of poetry too – we can see in his remark that in the style of the Elgin Marbles 'there is no alliteration or antithesis', there is no 'setness, squareness, affectation, or formality of appearance'. Here, he is thinking of Johnson's prose, just as in the essays it is Sir Joshua Reynolds' neoclassical theory he is contesting. He is also thinking of Burke, whom he refers to in the second essay on the Elgin Marbles, noting that the abrupt transitions in Burke's writing resemble both certain transitions in the marbles and Pindar's poetic style. The carvings are certainly classical but they are not to be understood in neoclassical terms. More than any other of the symbols Hazlitt uses, they embody English prose style.

In all these essays, we witness the activity of a critical imagination that magnificently unfolds its own powerful aesthetic – Hazlitt turns the critical essay into an art form so that it seems, as he says of Titian's paintings, 'sensitive and alive all over'.

– *Tom Paulin, 2008*

On the Elgin Marbles

On the Elgin Marbles: The Illisus

Who to the life an exact piece would make,
Must not from others' work a copy take;
No, not from Rubens or Vandyke:
Much less content himself to make it like
Th' ideas and the images which lie
In his own Fancy or his Memory.
No: he before his sight must place
The natural and living face;
The real object must command
Each judgment of his eye and motion of his hand.[1]

The true lesson to be learnt by our students and professors from the Elgin Marbles, is the one which the ingenious and honest Cowley has expressed in the above spirited lines. The great secret is to recur at every step to nature –

– To learn
Her manner, and with rapture taste her style.[2]

It is evident to anyone who views these admirable remains of antiquity (nay, it is acknowledged by our artists themselves, in despite of all the melancholy sophistry which they have been taught or have been teaching others for half a century) that the chief excellence of the figures depends on their having been copied from nature, and not from imagination. The communication of art with nature is here everywhere immediate, entire, palpable. The artist gives himself no fastidious airs of superiority over what he sees. He has not arrived at that stage of his progress described at much length in Sir Joshua Reynolds' *Discourses*, in which having served out his apprenticeship to nature, he can set up for himself in opposition to her. According to the old Greek form of drawing up the indentures in this

case, we apprehend they were to last for life. At least, we can compare these Marbles to nothing but human figures petrified: they have every appearance of absolute *facsimiles* or casts taken from nature. The details are those of nature; the masses are those of nature; the forms are from nature; the action is from nature; the whole is from nature. Let anyone, for instance, look at the leg of the Illisus or River-God, which is bent under him – let him observe the swell and undulation of the calf, the inter-texture of the muscles, the distinction and union of all the parts, and the effect of action everywhere impressed on the external form, as if the very marble were a flexible substance, and con-tained the various springs of life and motion within itself, and he will own that art and nature are here the same thing. It is the same in the back of the Theseus, in the thighs and knees, and in all that remains unimpaired of these two noble figures. It is not the same in the cast (which was shown at Lord Elgin's) of the famous *Torso* by Michael Angelo, the style of which that artist appears to have imitated too well. There every muscle has obviously the greatest prominence and force given to it of which it is capable in itself, not of which it is capable in connection with others. This fragment is an accumulation of mighty parts, without that play and reaction of each part upon the rest, without that 'alternate action and repose' which Sir Thomas Lawrence speaks of as characteristic of the Theseus and the Illisus, and which are as inseparable from nature as waves from the sea. The learned, however, here make a distinction, and suppose that the truth of nature is, in the Elgin Marbles, combined with ideal forms. If by *ideal forms* they mean fine natural forms, we have nothing to object; but if they mean that the sculptors of the Theseus and the Illisus got the forms out of their own heads, and then tacked the truth of nature to them, we can only say, 'Let them look again, let them look again.' We consider the Elgin Marbles as a demonstration of the impossibility of separating art from nature, without a proportionable loss at every remove. The utter absence of all setness of

appearance proves that they were done as studies from actual models. The separate parts of the human body may be given from scientific knowledge: – their modifications or inflections can only be learnt by seeing them in action; and the truth of nature is incompatible with ideal form, if the latter is meant to exclude actually existing form. The mutual action of the parts cannot be determined where the object itself is not seen. That the forms of these statues are not common nature, such as we see it every day, we readily allow: that they were not select Greek nature, we see no convincing reason to suppose. That truth of nature, and ideal or fine form, are not always or generally united, we know; but how they can ever be united in art, without being first united in nature, is to us a mystery, and one that we as little believe as understand!

Suppose, for illustration's sake, that these Marbles were originally done as casts from actual nature, and then let us inquire whether they would not have possessed all the same qualities that they now display, granting only, that the forms were in the first instance selected with the eye of taste, and disposed with a knowledge of the art and of the subject.

First, the larger masses and proportions of entire limbs and divisions of the body would have been found in the casts, for they would have been found in nature. The back, and trunk, and arms, and legs, and thighs, would have been there, for these are parts of the natural man, or actual living body, and not inventions of the artist, or ideal creations borrowed from the skies. There would have been the same sweep in the back of the Theseus; the same swell in the muscles of the arm on which he leans; the same division of the leg into calf and small, i.e. the same general results, or aggregation of parts, in the principal and most striking divisions of the body. The upper part of the arm would have been thicker than the lower, the thighs larger than the legs, the body larger than the thighs, in a cast taken from common nature; and in casts taken from the finest nature they would have been so in the same proportion, form and

manner, as in the statue of the Theseus, if the Theseus answers to the *idea* of the finest nature; for the idea and the reality must be the same; only, we contend that the idea is taken from the reality, instead of existing by itself, or being the creature of fancy. That is, there would be the same grandeur of proportions and parts in a cast taken from finely developed nature, such as the Greek sculptors had constantly before them, naked and in action, that we find in the limbs and masses of bone, flesh and muscle, in these much and justly admired remains.

Again, and incontestably, there would have been, besides the grandeur of form, all the *minutiae* and individual details in the cast that subsist in nature, and that find no place in the theory of *ideal* art – in the omission of which, indeed, its very grandeur is made to consist. The Elgin Marbles give a flat contradiction to this gratuitous separation of grandeur of design and exactness of detail, as incompatible in works of art, and we conceive that, with their whole ponderous weight to crush it, it will be difficult to set this theory on its legs again. In these majestic colossal figures, nothing is omitted, nothing is made out by negation. The veins, the wrinkles in the skin, the indications of the muscles under the skin (which appear as plainly to the anatomist, as the expert angler knows from an undulation on the surface of the water what fish is playing with his bait beneath it), the finger-joints, the nails, every smallest part cognisable to the naked eye, is given here with the same ease and exactness, with the same prominence, and the same subordination, that it would be in a cast from nature, i.e. in nature itself. Therefore, so far these things, viz. nature, a cast from it, and the Elgin Marbles, are the same; and all three are opposed to the fashionable and fastidious theory of the *ideal*. Look at Sir Joshua's picture of Puck, one of his finest-coloured, and most spirited performances. The fingers are mere *spuds*, and we doubt whether anyone can make out whether there are four toes or five allowed to each of the feet. If there had been a young Silenus among the Elgin Marbles, we don't know

that in some particulars it would have surpassed Sir Joshua's masterly sketch, but we are sure that the extremities, the nails, etc. would have been studies of natural history. The life, the spirit, the character of the grotesque and imaginary little being would not have made an abortion of any part of his natural growth or form.

Further, in a cast from nature there would be, as a matter of course, the same play and flexibility of limb or muscle, or, as Sir Thomas Lawrence expresses it, the same 'alternate action and repose', that we find so admirably displayed in the Elgin Marbles. It seems here as if stone could move: where one muscle is strained, another is relaxed, where one part is raised, another sinks in, just as in the ocean, where the waves are lifted up in one place, they sink proportionably low in the next: and all this modulation and affection of the different parts of the form by others arises from an attentive instantaneous observation of the parts of a flexible body, where the muscles and bones act upon, and communicate with, one another like the ropes and pulleys in a machine, and where the action or position given to a particular limb or membrane naturally extends to the whole body. This harmony, this combination of motion, this unity of spirit diffused through the wondrous mass and every part of it, is the glory of the Elgin Marbles: – put a well formed human body in the same position, and it will display the same character throughout; make a cast from it while in that position and action, and we shall still see the same bold, free, and comprehensive truth of design. There is no alliteration or antithesis in the style of the Elgin Marbles, no setness, square-ness, affectation, or formality of appearance. The different muscles do not present a succession of *tumuli*, each heaving with big throes to rival the other. If one is raised, the other falls quietly into its place. Neither do the different parts of the body answer to one another, like shoulder-knots on a lacquey's coat, or the different ornaments of a building. The sculptor does not proceed on architectural principles. His work has the freedom,

the variety, and stamp of nature. The form of corresponding parts is indeed the same, but it is to inflection from different circumstances. There is no primness or *petit-maîtreship*, as in some of the later antiques; where the artist seemed to think that flesh was glass or some other brittle substance; and that if it were put out of its exact shape it would break in pieces. Here, on the contrary, if the foot of one leg is bent under the body, the leg itself undergoes an entire alteration. If one side of the body is raised above the other, the original, or abstract, or *ideal* form of the two sides is not preserved strict and inviolable, but varies as it necessarily must do in conformity to the law of gravitation, to which all bodies are subject. In this respect, a cast from nature would be the same. Mr Chantrey once made a cast from Wilson the Black. He put him into an attitude at first, and made the cast, but not liking the effect when done, got him to sit again and made use of the plaster of Paris once more. He was satisfied with the result; but Wilson, who was tired with going through the operation, as soon as it was over, went and leaned upon a block of marble with his hands covering his face. The sagacious sculptor was so struck with the superiority of this natural attitude over those into which he had been arbitrarily put, that he begged him (if possible) to continue in it for another quarter of an hour, and another impression was taken off. All three casts remain, and the last is proof of the superiority of nature over art. The effect of lassitude is visible in every part of the frame, and the strong feeling of this affection, impressed on every limb and muscle, and venting itself naturally in an involuntary attitude which gave immediate relief, is that which strikes everyone who has seen this fine study from the life. The casts from this man's figure have been much admired: – it is from no superiority of form: it is merely that being taken from nature, they bear her 'image and superscription'.[3]

As to expression, the Elgin Marbles (at least the Ilissus and Theseus) afford no examples, the heads being gone.

Lastly, as to *ideal* form, we contend it is nothing but a selection of fine nature, such as it was seen by the ancient Greek sculptors; and we say that a sufficient approximation to this form may be found in our own country, and still more in other countries, at this day, to warrant the clear conclusion, that under more favourable circumstances of climate, manners, etc. no vain imagination of the human mind could come up to entire natural forms; and that actual casts from Greek models would rival the common Greek statues, or surpass them in the same proportion and manner as the Elgin Marbles do. Or if this conclusion should be doubted, we are ready at any time to produce at least one cast from living nature, which if it does not furnish practical proof of all that we have here advanced, we are willing to forfeit the last thing we can afford to part with – a theory!

If then the Elgin Marbles are to be considered an authority in subjects of art, we conceive the following principles, which have not hitherto been generally received or acted upon in Great Britain, will be found to result from them:

1. That art is (first and last) the imitation of nature.

2. That the highest art is the imitation of the finest nature, that is to say, of that which conveys the strongest sense of pleasure or power, of the sublime or beautiful.

3. That the *ideal* is only the selecting a particular form which expresses most completely the idea of a given character or quality, as of beauty, strength, activity, voluptuousness, etc. and which preserves that character with the greatest consistency throughout.

4. That the *historical* is nature in action. With regard to the face, it is expression.

5. That grandeur consists in connecting a number of parts into a whole, and not in leaving out the parts.

6. That as grandeur is the principle of connection between different parts, beauty is the principle of affinity between different forms, or their gradual conversion into each other.

The one harmonises, the other aggrandises our impressions of things.

7. That grace is the beautiful or harmonious in what relates to position or motion.

8. That grandeur of motion is unity of motion.

9. That strength is the giving the extremes, softness the uniting them.

10. That truth is to a certain degree beauty and grandeur, since all things are connected, and all things modify one another in nature. Simplicity is also grand and beautiful for the same reason. Elegance is ease and lightness, with precision.

All this we have, we believe, said before: we shall proceed to such proofs or explanations as we are able to give of it in another article.

First published in the *London Magazine*, 1822.

On the Elgin Marbles

At the conclusion of the former article on this subject, we ventured to lay down some general principles, which we shall here proceed to elucidate in such manner as we are able.

1. The first was, that *art is (first and last) the imitation of nature.*

By nature, we mean actually existing nature, or some one object to be found *in rerum natura*,[4] not an idea of nature existing solely in the mind, got from an infinite number of different objects, but which was never yet embodied in an individual instance. Sir Joshua Reynolds may be ranked at the head of those who have maintained the supposition that nature (or the universe of things) was indeed the groundwork or foundation on which art rested; but that the superstructure rose above it, that it towered by degrees above the world of realities, and was suspended in the regions of thought alone – that a middle form, a more refined idea, borrowed from the observation of a number of particulars, but unlike any of them, was the standard of truth and beauty, and the glittering phantom that hovered round the head of the genuine artist:

> So from the ground
> Springs lighter the green stalk, from thence the leaves
> More airy, last the bright consummate flower![5]

We have no notion of this vague, equivocal theory of art, and contend, on the other hand, that each image in art should have a *tally* or corresponding prototype in some object in nature. Otherwise, we do not see the use of art at all: it is a mere superfluity, an encumbrance to the mind, a piece of 'laborious foolery', – for the word, the mere name of any object or class of objects will convey the general idea, more free from particular details or defects than any the most neutral and indefinite

representation that can be produced by forms and colours. The word Man, for instance, conveys a more filmy, impalpable, abstracted, and (according to this hypothesis) sublime idea of the species, than Michael Angelo's *Adam*, or any real image can possibly do. If this then is the true object of art, the language of painting, sculpture, etc. becomes quite supererogatory. Sir Joshua and the rest contend, that nature (properly speaking) does not express any single individual, nor the whole mass of things as they exist, but a general principle, a *something common* to all these, retaining the perfections, that is, all in which they are alike, and abstracting the defects, namely, all in which they differ: so that, out of actual nature, we compound an artificial nature, never answering to the former in any one part of its mock existence, and which last is the true object of imitation to the aspiring artist. Let us adopt this principle of abstraction as the rule of perfection, and see what havoc it will make in all our notions and feelings in such matters. If the *perfect* is the *intermediate*, why not confound all objects, all forms, all colours at once? Instead of painting a landscape with blue sky, or white clouds, or the green earth, or grey rocks and towers; what should we say, if the artist (so named) were to treat all these 'fair varieties' as so many imperfections and mistakes in the creation, and mass them all together, by mixing up the colours on his palette in the same dull leaden tone, and call this the true principle of epic landscape-painting? Would not the thing be abominable, an abortion, and worse than the worst Dutch picture? Variety then is one principle, one beauty in external nature, and not an everlasting source of pettiness and deformity, which must be got rid of at all events, before taste can set its seal upon work, or fancy own it. But it may be said, it is different in things of the same species, and particularly in man, who is cast in a regular mould, which mould is one. What then, are we, on this pretext, to confound the difference of sex in a sort of hermaphrodite softness, as Mr Westall, Angelica Kauffman, and others, have done in their effeminate

performances? Are we to leave out of the scale of legitimate art, the extremes of infancy and old age, as not *middle terms* in man's life? Are we to strike off from the list of available topics and sources of interest, the varieties of character, of passion, of strength, activity, etc.? Is every thing to wear the same form, the same colour, the same unmeaning face? Are we only to repeat the same average idea of perfection, that is, our own want of observation and imagination, for ever, and to melt down the inequalities and excrescences of individual nature in the monotony of abstraction? Oh no! As well might we prefer the cloud to the rainbow; the dead corpse to the living moving body! So Sir Joshua debated upon Rubens' landscapes, and has a whole chapter to inquire whether *accidents in nature*, that is, rainbows, moonlight, sunsets, clouds and storms, are the proper thing in the classical style of art. Again, it is urged, that this is not what is meant, viz. to exclude different classes or characters of things, but that there is in each class or character a *middle point*, which is the point of perfection. What middle point? Or how is it ascertained? What is the middle age of childhood? Or are all children to be alike, dark or fair? Some of Titian's children have black hair, and others yellow or auburn: who can tell which is the most beautiful? May not a St John be older than an infant Christ? Must not a Magdalen be different from a Madonna, a Diana from a Venus? Or may not a Venus have more or less gravity, a Diana more or less sweetness? What then becomes of the abstract idea in any of these cases? It varies as it does in nature; that is, there is indeed a general principle or character to be adhered to, but modified everlastingly by various other given or nameless circumstances. The highest art, like nature, is a living spring of unconstrained excellence, and does not produce a continued repetition of itself, like plaster casts from the same figure. But once more it may be insisted, that in what relates to mere form or organic structure, there is necessarily a middle line or central point, any thing short of which is deficiency, and anything beyond it excess, being the average

form to which all the other forms included in the same species tend, and approximate more or less. Then this average form as it exists in nature should be taken as the model for art. What occasion to do it out of your own head, when you can bring it under the cognisance of your senses? Suppose a foot of a certain size and shape to be the standard of perfection, or if you will, *the mean proportion* between all other feet. How can you tell this so well as by seeing it? How can you copy it so well as by having it actually before you? But, you will say, there are particular defects in the best shaped actual foot which ought not to be transferred to the imitation. Be it so. But are there not also particular minute beauties in the best, or even the worst shaped actual foot, which you will only discover by ocular inspection, which are reducible to no measurement or precepts, and which in finely developed nature outweigh the imperfections a thousand fold, the proper general form being contained there also, and these being only the distinctly articulated parts of it with their inflections which no artist can carry in his head alone? For instance, in the bronze monument of Henry VII and his wife, in Westminster Abbey, by the famous Torregiano, the fingers and finger nails of the woman in particular are made out as minutely, and, at the same time, as beautifully as it is possible to conceive; yet they have exactly the effect that a cast taken from a fine female hand would have, with every natural joint, muscle, and nerve, in complete preservation. Does this take from the beauty or magnificence of the whole? No: it aggrandises it. What then does it take from? Nothing but the conceit of the artist that he can paint a hand out of his own head (that is, out of nothing, and by reducing it again as near as can be to nothing, to a mere vague image) that shall be better than any thing in nature. A hand, or foot, is not *one thing*, because it is *one word* or name; and the painter of mere abstractions had better lay down his pencil at once, and be contented to write the descriptions or titles under works of art. Lastly, it may be objected that a whole figure can never be found perfect or equal; that the most

beautiful arm will not belong to the same figure as the most beautiful leg, and so on. How is this to be remedied? By the arm from one, and the leg from the other, and clapping both on the same body? That will never do; for however admirable in themselves, they will hardly agree together. One will have a different character from the other; and they will form a sort of natural patchwork. Or, to avoid this, will you take neither from actual models, but derive them from the neutralising medium of your own imagination. Worse and worse. Copy them from the same model, the best in all its parts you can get; so that if you have to alter, you alter as little as possible, and retain nearly the whole substance of nature.* You may depend upon it that what is so retained, will alone be of any specific value. The rest may have a negative merit, but will be positively good for nothing. It will be to the vital truth and beauty of what is taken from the best nature, like the piecing of an antique statue. It fills a gap, but nothing more. It is, in fact, a mental blank.

2. This leads us to the second point laid down before, which was, that *the highest art is the imitation of the finest nature, or in other words, of that which conveys the strongest sense of pleasure or power, of the sublime or beautiful.*

The artist does not pretend to *invent* an absolutely new class of objects, without any foundation in nature. He does not spread his palette on the canvas, for the mere finery of the thing, and tell us that it makes a brighter show than the rainbow, or even than a bed of tulips. He does not draw airy forms, moving above the earth, 'gay creatures of the element, that play i' th' plighted clouds', and scorn the mere material existences, the concrete descendants of those that came out of Noah's Ark, and that walk, run, or creep upon it. No, he does not paint only what he has seen *in his mind's eye* but the common objects that both he and others daily meet – rocks, clouds, trees, men, women, beasts,

* I believe this rule will apply to all grotesques, which are evidently taken from opposite natures.

fishes, birds, or what he calls such. He is then an imitator by profession. He gives the appearances of things that exist outwardly by themselves, and have a distinct and independent nature of their own. But these know their own nature best; and it is by consulting them that he can alone trace it truly, either in the immediate details, or characteristic essences. Nature is consistent, unaffected, powerful, subtle: art is forgetful, apish, feeble, coarse. Nature is the original, and therefore right: art is the copy, and can but tread lamely in the same steps. Nature penetrates into the parts, and moves the whole mass: it acts with diversity, and in necessary connection; for real causes never forget to operate, and to contribute their portion. Where, therefore, these causes are called into play to the utmost extent that they ever go to, there we shall have a strength and a refinement, that art may imitate but cannot surpass. But it is said that art can surpass the most perfect image in nature by combining others with it. What! by joining to the most perfect of its kind something less perfect? Go to, – this argument will not pass. Suppose you have a goblet of the finest wine that ever was tasted: you will not mend it by pouring into it all sorts of samples of an inferior quality. So the best in nature is the stint and limit of what is best in art: for art can only borrow from nature still; and, moreover, must borrow entire objects, for bits only make patches. We defy any landscape painter to invent out of his own head, and by jumbling together all the different forms of hills he ever saw, by adding a bit to one and taking a bit from another, any thing equal to Arthur's Seat, with the appendage of Salisbury Crags, that overlook Edinburgh. Why so? Because there are no levers in the mind of man equal to those with which nature works at her utmost need. No imagination can toss and tumble about huge heaps of earth as the ocean in its fury can. A volcano is more potent to rend rocks asunder than the most splashing pencil. The convulsions of nature can make a precipice more frightfully, or heave the backs of mountains more proudly, or throw their sides into waving lines more gracefully than all the

beau idéal of art. For there is in nature not only greater power and scope, but (so to speak) greater knowledge and unity of purpose. Art is comparatively weak and incongruous, being at once a miniature and caricature of nature. We grant that a tolerable sketch of Arthur's Seat, and the adjoining view, is better than Primrose Hill itself; (dear Primrose Hill! ha! faithless pen, canst thou forget its winding slopes, and valleys green, to which all Scotland can bring no parallel?) but no pencil can transform or dandle Primrose Hill (our favourite Primrose Hill) into a thing of equal character and sublimity with Arthur's Seat. It gives us some pain to make this concession; but in doing it, we flatter ourselves that no Scotchman will have the liberality in any way to return us the compliment. We do not recollect a more striking illustration of the difference between art and nature in this respect, than Mr Martin's very singular, and, in some things, very meritorious pictures. But he strives to outdo nature. He wants to give more than she does, or than his subject requires or admits. He subdivides his groups into infinite littleness, and exaggerates his scenery into absolute immensity. His figures are like rows of shiny pins; his mountains are piled up one upon the back of the other, like the storeys of houses. He has no notion of the moral principle in all art, that a part may be greater than the whole. He reckons that if one range of lofty square hills is good, another range above that with clouds between must be better. He thus wearies the imagination, instead of exciting it. We see no end of the journey, and turn back in disgust. We are tired of the effort, we are tired of the monotony of this sort of re-duplication of the same object. We were satisfied before; but it seems the painter was not, and we naturally sympathise with him. This craving after quantity is a morbid affection. A landscape is not an architectural elevation. You may build a house as high as you can lift up stones with pulleys and levers, but you cannot raise mountains into the sky merely with the pencil. They lose probability and effect by striving at too much; and, with their ceaseless throes, oppress the imagination of the

spectator, and bury the artist's fame under them. The only error of these pictures is, however, that art here puts on her seven-league boots, and thinks it possible to steal a march upon nature. Mr Martin might make Arthur's Seat sublime, if he chose to take the thing as it is; but he would be for squaring it according to the mould in his own imagination, and for clapping Arthur's Seat on the top of it, to make the Calton Hill stare! Again, with respect to the human figure. This has an internal structure, bones, blood vessels, etc. by means of which the external surface is operated upon according to certain laws. Does the artist, with all his generalisations, understand these, as well as nature does? Can he predict, with all his learning, that if a certain muscle is drawn up in a particular manner, it will present a particular appearance in a different part of the arm or leg, or bring out other muscles, which were before hid, with certain modifications? But in nature all this is brought about by necessary laws, and the effect is visible to those, and those only, who look for it in actual objects. This is the great and master-excellence of the ELGIN MARBLES, that they do not seem to be the outer surface of a hard and immovable block of marble, but to be actuated by an internal machinery, and composed of the same flexible materials as the human body. The skin (or the outside) seems to be protruded or tightened by the natural action of a muscle beneath it. This result is miraculous in art: in nature it is easy and unavoidable. That is to say, art has to imitate or produce effects or appearances without the natural causes: but the human understanding can hardly be so true to those causes as the causes to themselves; and hence the necessity (in this sort of *simulated creation*) of recurring at every step to the actual objects and appearances of nature. Having shown so far how indispensable it is for art to identify itself with nature, in order to preserve the truth of imitation, without which it is destitute of value or meaning, it may be said to follow as a necessary consequence, that the only way in which art can rise to greater dignity or excellence is by finding out models of greater dignity

and excellence in nature. Will anyone, looking at the Theseus, for example, say that it could spring merely from the artist's brain, or that it could be done from a common, ill-made, or stunted body? The fact is, that its superiority consists in this, that it is a perfect combination of art and nature, or an identical, and as it were spontaneous copy of an individual picked out of a finer race of men than generally tread this ball of earth. Could it be made of a Dutchman's trunk-hose? No. Could it be made out of one of Sir Joshua's *Discourses* on the *middle form*? No. How then? Out of an eye, a head, and a hand, with sense, spirit, and energy to follow the finest nature, as it appeared exemplified in sweeping masses, and in subtle details, without pedantry, conceit, cowardice, or affectation! Some one was asking at Mr H—yd—n's one day, as a few persons were looking at the cast from this figure, why the original might not have been done as a cast from nature? Such a supposition would account at least for what seems otherwise unaccountable – the incredible labour and finishing bestowed on the back and other parts of this figure, placed at a prodigious height against the walls of a temple, where they could never be seen after they were once put up there. If they were done by means of a cast in the first instance, the thing appears intelligible, otherwise not. Our host stoutly resisted this imputation, which tended to deprive art of one of its greatest triumphs, and to make it as mechanical as a shaded profile. So far, so good. But the reason he gave was bad, viz. that the limbs could not remain in those actions long enough to be cast. Yet surely this would take a shorter time than if the model sat to the sculptor; and we all agreed that nothing but actual, continued, and intense observation of living nature could give the solidity, complexity, and refinement of imitation which we saw in the half animated, almost moving figure before us.* Be this as it may, the principle

* Someone finely applied to the repose of this figure the words: 'Sedet, in eternumque sedebit / Infelix Theseus'.[6]

here stated does not reduce art to the imitation of what is understood by common or low life. It rises to any point of beauty or sublimity you please, but it rises only as nature rises exalted with it too. To hear these critics talk, one would suppose there was nothing in the world really worth looking at. The Dutch pictures were the best that they could paint: they had no other landscapes or faces before them. *Honi soit qui mal y pense.*[7] Yet who is not alarmed at a Venus by Rembrandt? The Greek statues were (*cum grano salis*[8]) Grecian youths and nymphs; and the women in the streets of Rome (it had been remarked*) look to this hour as if they had walked out of Raphael's pictures. Nature is always truth: at its best, it is beauty and sublimity as well; though Sir Joshua tells us in one of the papers in the *Idler* that in itself, or with reference to individuals, it is a mere tissue of meanness and deformity. Luckily, the Elgin Marbles say NO to that conclusion: for they are decidedly *part and parcel thereof*. What constitutes fine nature, we shall inquire under another head. But we would remark here, that it can hardly be the *middle form*, since this principle, however it might determine certain general proportions and outlines, could never be intelligible in the details of nature, or applicable to those of art. Who will say that the form of a finger nail is just midway between a thousand others that he has *not* remarked: we are only struck with it when it is more than ordinarily beautiful, from symmetry, an oblong shape, etc. The staunch partisans of this theory, however, get over the difficulty here spoken of, in practice, by omitting the details altogether, and making their work sketches, or rather what the French call *ébauches*, and the English *daubs*.

3. *The IDEAL is only the selecting a particular form which expresses most completely the idea of a given character or quality, as of beauty, strength, activity, voluptuousness, etc. and which preserves that character with the greatest consistency throughout.*

* By Mr Coleridge.

Instead of its being true in general that the *ideal* is the *middle point*, it is to be found in the *extremes*; or, it is carrying any *idea* as far as it will go. Thus, for instance, a Silenus is as much an *ideal* thing as an Apollo, as to the principle on which it is done, viz. giving to every feature, and to the whole form, the utmost degree of grossness and sensuality that can be imagined, with this exception (which has nothing to do with the understanding of the question), that the *ideal* means by custom this extreme on the side of the good and beautiful. With this reserve, the *ideal* means always the *something more* thing which may be anticipated by the fancy, and which must be found in nature (by looking long enough for it) to be expressed as it ought. Suppose a good heavy Dutch face (we speak by the proverb) – this, you will say, is gross; but it is not gross enough. You have an idea of something grosser, that is, you have seen something grosser and must seek for it again. When you meet with it, and have stamped it on the canvas, or carved it out of the block, this is the true *ideal*, namely, that which answers to and satisfies a preconceived idea; not that which is made out of an abstract idea, and answers to nothing. In the Silenus, also, according to the notion we have of the properties and character of that figure, there must be vivacity, slyness, wantonness, etc. Not only the image in the mind, but a real face may express all these combined together; another may express them more, and another most, which last is the *ideal*; and when the image in nature coalesces with, and gives a body, force, and reality to the idea in the mind, then it is that we see the true perfection of art. The forehead should be 'villainous low'; the eyebrows bent in; the eyes small and gloating; the nose *pugged*, and pointed at the end, with distended nostrils; the mouth large and shut; the cheeks swollen; the neck thick, etc. There is, in all this process, nothing of softening down, of compromising qualities, of finding out a *mean proportion* between different forms and characters; the sole object is to *intensify* each as much as possible. The only fear is 'to o'erstep the modesty of nature' and run into

caricature. This must be avoided; but the artist is only to stop short of this. He must not outrage probability. We must have seen a class of such faces, or something so nearly approaching, as to prevent the imagination from revolting against them. The forehead must be low, but not so low as to lose the character of humanity in the brute. It would thus lose all its force and meaning. For that which is extreme and ideal in one species, is nothing, if, by being pushed too far, it is merged in another. Above all, there should be *keeping* in the whole and every part. In the Pan, the horns and goat's feet, perhaps, warrant the approach to a more *animal* expression than would otherwise be allowable in the human features; but yet this tendency to excess must be restrained within certain limits. If Pan is made into a beast, he will cease to be a God! Let Momus distend his jaws with laughter, as far as laughter can stretch them, but no further; or the expression will be that of pain and not of pleasure. Besides, the overcharging the expression or action of any one feature will suspend the action of others. The whole face will no longer laugh. But the universal suffusion of broad mirth and humour over the countenance is very different from a placid smile, midway between grief and joy. Yet a classical Momus, by modern theories of the *ideal*, ought to be such a nonentity in expression. The ancients knew better. They pushed art in such subjects to the verge of 'all we hate', while they felt the point beyond which it could not be urged with propriety, i.e. with truth, consistency, and consequent effect. – There is no difference, in philosophical reasoning, between the mode of art here insisted on, and the *ideal* regularity of such figures as the Apollo, the Hercules, the Mercury, the Venus, etc. All these are, as it were, *personifications*, *essences*, *abstractions* of certain qualities or virtues in human nature, not of human nature in general, which would make nonsense. Instead of being abstractions of all sorts of qualities jumbled together in a neutral character, they are in the opposite sense *abstractions* of some single quality or customary combination of qualities, leaving out all others as much

as possible, and imbuing every part with that one predominant character to the utmost. The Apollo is a representation of graceful dignity and mental power; the Hercules of bodily strength; the Mercury of swiftness; the Venus of female loveliness, and so on. In these, in the Apollo, is surely implied and found more grace than usual; in the Hercules more strength than usual; in the Mercury more lightness than usual; in the Venus more softness than usual. Is it not so? What then becomes of the pretended *middle form*? One would think it would be sufficient to prove this, to ask, 'Do not these statues differ from one another? And is this difference a defect?' It would be ridiculous to call them by different names, if they were not supposed to represent different and peculiar characters: sculptors should, in that case, never carve any thing but the statue of *a man*, the statue of a *woman*, etc. and this would be the name of perfection. This theory of art is not at any rate justified by the history of art. An extraordinary quantity of bone and muscle is as proper to the Hercules as his club, and it would be strange if the Goddess of Love had not a more delicately rounded form, and a more languishing look withal, than the Goddess of Hunting. That a form combining and blending the properties of both, the downy softness of the one, with the elastic buoyancy of the other, would be more perfect than either, we no more see than that grey is the most perfect of colours. At any rate, this is the march neither of nature nor of art. It is not denied that these antique sculptures are models of the *ideal*; nay, it is on them that this theory boasts of being founded. Yet they give a flat contradiction to its insipid mediocrity. Perhaps some of them have a slight bias to the false ideal, to the smooth and uniform, or the negation of nature: any error on this side is, however, happily set right by the ELGIN MARBLES, which are the paragons of sculpture and the mould of form. – As the *ideal* then requires a difference of character in each figure as a whole, so it expects the same character (or a corresponding one) to be stamped on each part of every figure. As the legs of a Diana should be more muscular and adapted for

running, than those of a Venus or a Minerva, so the skin of her fare ought to be more tense, bent on her prey, and hardened by being exposed to the winds of heaven. The respective characters of lightness, softness, strength, etc. should pervade each part of the surface of each figure, but still varying according to the texture and functions of the individual part. This can only be learned or practised from an attentive observation of nature in those forms in which any given character or excellence is most strikingly displayed, and which has been selected for imitation and study on that account. – Suppose a dimple in the chin to be a mark of voluptuousness; then the Venus should have a dimple in the chin; and she has one. But this will imply certain correspondent indications in other parts of the features, about the corners of the mouth, a gentle undulation and sinking in of the cheek, as if it had just been pinched, and so on: yet so as to be consistent with the other qualities of roundness, smoothness, etc. which belong to the idea of the character. Who will get all this and embody it out of the idea of a *middle form*, I cannot say: it may be, and has been, got out of the idea of a number of distinct enchanting graces in the mind, and from some heavenly object unfolded to the sight!

4. That the historical is nature in action. With regard to the face, it is expression.

Hogarth's pictures are true history. Every feature, limb, figure, group, is instinct with life and motion. He does not take a subject and place it in a position, like a lay figure, in which it stirs neither limb nor joint. The scene moves before you: the face is like a framework of flexible machinery. If the mouth is distorted with laughter, the eyes swim in laughter. If the forehead is knit together, the cheeks are puckered up. If a fellow squints most horribly, the rest of his face is awry. The muscles pull different ways, or the same way, at the same time, on the surface of the picture, as they do in the human body. What you see is the reverse of *still life*. There is a continual and complete action and reaction of one variable part upon another, as there is

in the ELGIN MARBLES. If you pull the string of a bow, the bow itself is bent. So it is in the strings and wires that move the human frame. The action of any one part, the contraction or relaxation of any one muscle, extends more or less perceptibly to every other: 'Thrills in each nerve, and lives along the line.'9

Thus the celebrated Iö of Correggio is imbued, steeped in a manner in the same voluptuous feeling all over – the same passion languishes in her whole frame, and communicates the infection to the feet, the back, and the reclined position of the head. This is history, not carpenter's work. Some painters fancy that they paint history, if they get the measurement from the foot to the knee, and put four bones where there are four bones. This is not our idea of it; but we think it is to show how one part of the body sways another in action and in passion. The last relates chiefly to the expression of the face, though not altogether. Passion may be shown in a clenched fist as well as in clenched teeth. The face, however, is the throne of expression. Character implies the feeling, which is fixed and permanent; expression that which is occasional and momentary, at least, technically speaking. Portrait treats of objects as they are; history of the events and changes to which they are liable. And so far history has a double superiority; or a double difficulty to overcome, viz. in the rapid glance over a number of parts subject to the simultaneous action of the same law, and in the scope of feeling required to sympathise with the critical and powerful movements of passion. It requires greater capacity of muscular motion to follow the progress of a carriage in violent motion, than to lean upon it standing still. If, to describe passion, it were merely necessary to observe its outward effects, these, perhaps, in the prominent points, become more visible and more tangible as the passion is more intense. But it is not only necessary to see the effects, but to discern the cause, in order to make the one true to the other. No painter gives more of intellectual and impassioned appearances than he understands or feels. It is an axiom in painting, that sympathy is

indispensable to truth of expression. Without it, you get only caricatures, which are not the thing. But to sympathise with passion, a greater fund of sensibility is demanded in proportion to the strength or tenderness of the passion. And as he feels most of this whose face expresses most passion, he also feels most by sympathy whose hand can describe most passion. This amounts nearly, we take it, to a demonstration of an old and very disputed point. The same reasoning might be applied to poetry, but this is not the place. – Again, it is easier to paint a portrait than an historical face, because the head *sits* for the first, but the expression will hardly *sit* for the last. Perhaps those passions are the best subjects for painting, the expression of which may be retained for some time, so as to be better caught, which throw out a sort of lambent fire, and leave a reflected glory behind them, as we see in Madonna's, Christ's Heads, and what is understood by sacred subjects in general. The violences of human passion are too soon over to be copied by the hand, and the mere conception of the internal workings is not here sufficient, as it is in poetry. A portrait is to history what still life is to portraiture: that is, the whole remains the same while you are doing it, or while you are occupied about each part, the rest wait for you. Yet, what a difference is there between taking an original portrait, and making a copy of one! This shows that the face in its most ordinary state is continually varying and in action. So much of history is there in portrait! – No one should pronounce definitively on the superiority of history over portrait, without recollecting Titian's heads. The finest of them are very nearly (say quite) equal to the finest of Raphael's. They have almost the look of *still life*, yet each part is decidedly influenced by the rest. Every thing is *relative* in them. You cannot put any other eye, nose, lip, in the same face. As is one part, so is the rest. You cannot fix on any particular beauty; the charm is in the whole. They have least action, and the most expression of any portraits. They are doing nothing, and yet all other business seems insipid in comparison of their thoughts. They

are silent, retired, and do not court observation; yet you cannot keep your eyes from them. Someone said, that you would be as cautious of your behaviour in a room where a picture of Titian's was hung, as if there was somebody by – so entirely do they look you through. They are the least tiresome *furniture company* in the world!

5. *Grandeur consists in connecting a number of parts into a whole, and not in leaving out the parts.*

Sir Joshua lays it down that the great style in art consists in the omission of the details. A greater error never man committed. The great style consists in preserving the masses and general proportions; not in omitting the details. Thus, suppose, for illustration's sake, the general form of an eyebrow to be commanding and grand. It is of a certain size, and arched in a particular curve. Now, surely, this general form or outline will be equally preserved, whether the painter daubs it in, in a bold, rough way, as Reynolds or perhaps Rembrandt would, or produces the effect by a number of hairlines arranged in the same form as Titian sometimes did; and in his best pictures. It will not be denied (for it cannot) that the characteristic form of the eyebrow would be the same, or that the effect of the picture at a small distance would be nearly the same in either case; only in the latter, it would be rather more perfect, as being more like nature. Suppose a strong light to fall on one side of a face, and a deep shadow to involve the whole of the other. This would produce two distinct and large masses in the picture; which answers to the conditions of what is called the grand style of composition. Well, would it destroy these masses to give the smallest veins or variation of colour or surface in the light side, or to shade the other with the most delicate and elaborate chiaroscuro? It is evident not; from common sense, from the practice of the best masters, and, lastly, from the example of nature, which contains both the larger masses, the strongest contrasts, and the highest finishing, within itself. The integrity of the whole, then, is not impaired by the indefinite subdivision

and smallness of the parts. The grandeur of the ultimate effects depends entirely on the arrangement of these in a certain form or under certain masses. The Ilissus or River-God (of which we have given a print in a former number) is floating in his proper element, and is, in appearance, as firm as a rock, as pliable as a wave of the sea. The artist's breath might be said to mould and play upon the undulating surface. The whole is expanded into noble proportions, and heaves with general effect. What then? Are the parts unfinished; or are they not there? No; they are there with the nicest exactness, but in due subordination; that is, they are there as they are found in fine nature; and float upon the general form, like straw or weeds upon the tide of ocean. Once more: in Titian's portraits we perceive a certain character stamped upon the different features. In the *Hippolito de Medici* the eyebrows are angular, the nose is peaked, the mouth has sharp corners, the face is (so to speak) a pointed oval. The drawing in each of these is as careful and distinct as can be. But the unity of intention in nature, and in the artist, does not the less tend to produce a general grandeur and impressiveness of effect; which at first sight it is not easy to account for. To combine a number of particulars to one end is not to omit them altogether; and is the best way of producing the grand style, because it does this without either affectation or slovenliness.

6. The sixth rule we proposed to lay down was, that *as grandeur is the principle of connection between different parts; beauty is the principle of affinity between different forms, or their gradual conversion into each other. The one harmonises, the other aggrandises, our impressions of things.*

There is a harmony of colours and a harmony of sounds, unquestionably: why then there should be all this squeamishness about admitting an original harmony of forms as the principle of beauty and source of pleasure there we cannot understand. It is true, that there is in organised bodies a certain standard of form to which they approximate more or less, and from which they cannot very widely deviate without shocking

the sense of custom, or our settled expectations of what they ought to be. And hence it has been pretended, that there is in all such cases a *middle central form*, obtained by leaving out the peculiarities of all the others, which alone is the pure standard of truth and beauty. A conformity to custom is, we grant, one condition of beauty or source of satisfaction to the eye, because an abrupt transition shocks; but there is a conformity (or correspondence) of colours, sounds, lines, among themselves, which is soft and pleasing for the same reason. The average or customary form merely determines what is *natural*. A thing cannot please, unless it is to be found in nature; but that which is natural is most pleasing, according as it has other properties which in themselves please. Thus the colour of a cheek must be the natural complexion of a human face; – it would not do to make it the colour of a flower or a precious stone; – but among complexions ordinarily to be found in nature, that is most beautiful which would be thought so abstractedly, or in itself. Yellow hair is not the most common, nor is it a mean proportion between the different colours of women's hair. Yet, who will say that it is not the most beautiful? Blue or green hair would be a defect and an anomaly, not because it is not the *medium* of nature, but because it is not in nature at all. To say that there is no difference in the sense of form except from custom, is like saying that there is no difference in the sensation of smooth or rough. Judging by analogy, a gradation or symmetry of form must affect the mind in the same manner as a gradation of recurrence at given intervals of tones or sounds; and if it does so in fact, we need not inquire further for the principle. Sir Joshua (who is the arch-heretic on this subject) makes grandeur or sublimity consist in the middle form, or abstraction of all peculiarities; which is evidently false, for grandeur and sublim-ity arise from extraordinary strength, magnitude, etc. or in a word, from an excess of power, so as to startle and overawe the mind. But as sublimity is an excess of power, beauty is, we conceive, the blending and harmonising different powers or

qualities together, so as to produce a soft and pleasurable sensation. That it is not the middle form of the species seems proved in various ways. First, because one species is more beautiful than another, according to common sense. A rose is the queen of flowers, in poetry at least; but in this philosophy any other flower is as good. A swan is more beautiful than a goose, a stag, than a goat. Yet if custom were the test of beauty, either we should give no preference, or our preference would be reversed. Again, let us go back to the human face and figure. A straight nose is allowed to be handsome, that is, one that presents nearly a continuation of the line of the forehead, and the sides of which are nearly parallel. Now this cannot be the mean proportion of the form of noses. For, first, most noses are broader at the bottom than at the top, inclining to the Negro head, but none are broader at top than at the bottom, to produce the Greek form as a balance between both. Almost all noses sink in immediately under the forehead bone, none ever project there; so that the nearly straight line continued from the forehead cannot be a mean proportion struck between the two extremes of convex and concave form in this feature of the face. There must, therefore, be some other principle of symmetry, continuity, etc. to account for the variation from the prescribed rule. Once more (not to multiply instances tediously), a double calf is undoubtedly the perfection of beauty in the form of the leg. But this is a rare thing. Nor is it the medium between two common extremes. For the muscles seldom swell enough to produce this excrescence, if it may be so called, and never run to an excess there, so as, by diminishing the quantity, to subside into proportion and beauty. But this second or lower calf is a connecting link between the upper calf and the small of the leg, and is just like a second chord or half note in music. We conceive that anyone who does not perceive the beauty of the *Venus de Medicis*, for instance, in this respect, has not the proper perception of form in his mind. As this is the most disputable, or at least the most disputed part of our

theory, we may, perhaps, have to recur it again, and shall leave an opening for that purpose.

7. That grace is the beautiful or harmonious in what relates to position or motion.

There needs not much be said on this point; as we apprehend it will be granted, that whatever beauty is as to the form, grace is the same thing in relation to the use that is made of it. Grace, in writing, relates to the transitions that are made from one subject to another, or to the movement that is given to a passage. If one thing leads to another, or an idea or illustration is brought in without effect, or without making a *boggle* in the mind, we call this a graceful style. Transitions must in general be gradual and pieced together. But sometimes the most violent are the most graceful, when the mind is fairly tired out and exhausted with a subject, and is glad to leap to another as a repose and relief from the first. Of these there are frequent instances in Mr Burke's writings, which have something Pindaric in them. That which is not beautiful in itself, or in the mere form, may be made so by position or motion. A figure by no means elegant may be put in an elegant position. Mr Kean's figure is not good; yet we have seen him throw himself into attitudes of infinite spirit, dignity, and grace. John Kemble's figure, on the contrary, is fine in itself; and he has only to show himself to be admired. The direction in which any thing is moved has evidently nothing to do with the shape of the thing moved. The one may be a circle and the other a square. Little and deformed people seem to be well aware of this distinction, who, in spite of their unpromising appearance, usually assume the most imposing attitudes, and give themselves the most extraordinary airs imaginable.

8. Grandeur of motion is unity of motion.

This principle hardly needs illustration. Awkwardness is contradictory or disjointed motion.

9. Strength in art is giving the extremes, softness the uniting them.

There is no incompatibility between strength and softness, as is sometimes supposed by frivolous people. Weakness is not refinement. A shadow may be twice as deep in a finely coloured picture as in another, and yet almost imperceptible, from the gradations that lead to it, and blend it with the light. Correggio had prodigious strength, and greater softness. Nature is strong and soft, beyond the reach of art to imitate. Softness then does not imply the absence of considerable extremes, but it is the interposing a third thing between them, to break the force of the contrast. Guido is more soft than strong. Rembrandt is more strong than soft.

10. And lastly. *That truth is, to a certain degree, beauty and grandeur, since all things are connected, and all things modify one another in nature. Simplicity is also grand and beautiful for the same reason. Elegance is ease and lightness, with precision.*

This last head appears to contain a number of *gratis dicta*,[10] got together for the sake of completing a decade of propositions. They have, however, some show of truth, and we should add little clearness to them by any reasoning upon the matter. So we will conclude here for the present.

First published in the *London Magazine*, 1822.

'Prose Style and the Elgin Marbles'

It were to be wished that the French sculptors would come over and look at the Elgin Marbles, as they are arranged with great care and some pomp in the British Museum. They may smile to see that we are willing to remove works of art from their original places of abode, though we will not allow others to do so. These noble fragments of antiquity might startle our fastidious neighbours a little at first from their rude state and their simplicity, but I think they would gain upon them by degrees, and convince their understandings, if they did not subdue their affections. They are indeed an equally instructive lesson and unanswerable rebuke to them and to us – to them for thinking that finishing every part *alike* is perfection, and to us who imagine that to leave every part alike unfinished is grandeur. They are as remote from finicalness as grossness, and combine the parts with the whole in the manner that nature does. Every part is given, but not ostentatiously, and only as it would appear in the circumstances. There is an alternate action and repose. If one muscle is strained, another is proportionably relaxed. If one limb is in action and another at rest, they come under different law, and the muscles are not brought out nor the skin tightened in the one as in the other. There is a flexibility and sway of the limbs and of the whole body. The flesh has the softness and texture of flesh, not the smoothness or stiffness of stone. There is an undulation and a liquid flow on the surface, as the breath of genius moved the mighty mass: they are the finest forms in the most striking attitudes, and with every thing in its place, proportion, and degree, uniting the ease, truth, force, and delicacy of Nature. They show nothing but the artist's thorough comprehension of, and entire docility to that great teacher. There is no *petit-maîtreship*, no pedantry, no attempt at a display of science, or at forcing the parts into an artificial symmetry, but it is like cutting a human body out of a block of marble, and

leaving it to act for itself with all the same springs, levers, and internal machinery. It was said of Shakespeare's dramas, that they were the *logic of passion*; and it may be affirmed of the Elgin Marbles, that they are the *logic of form*. – One part being given, another cannot be otherwise than it is. There is a mutual understanding and reaction throughout the whole frame. The Apollo and other antiques are not equally simple and severe. The limbs have too much an appearance of being cased in marble, of making a display of every recondite beauty, and of balancing and answering to one another, like the rhymes in verse. The Elgin Marbles are harmonious, flowing, varied prose. In a word, they are like casts after the finest nature. Any cast from nature, however inferior, is in the same style. Let the French and English sculptors make casts continually. The one will see in them the parts everywhere given – the other will see them everywhere given in subordination to, and as forming materials for, a whole.

First published in the *Morning Chronicle*, 1824.

On the Pleasure of Painting

> There is a pleasure in painting which none but painters know.
> – William Cowper, *The Task*

In writing, you have to contend with the world; in painting, you have only to carry on a friendly strife with Nature. You sit down to your task, and are happy. From the moment that you take up the pencil, and look Nature in the face, you are at peace with your own heart. No angry passions rise to disturb the silent progress of the work, to shake the hand, or dim the brow: no irritable humours are set afloat: you have no absurd opinions to combat, no point to strain, no adversary to crush, no fool to annoy – you are actuated by fear or favour to no man. There is 'no juggling here', no sophistry, no intrigue, no tampering with the evidence, no attempt to make black white, or white black: but you resign yourself into the hands of a greater power, that of Nature, with the simplicity of a child, and the devotion of an enthusiast – 'study with joy her manner, and with rapture taste her style.' The mind is calm, and full at the same time. The hand and eye are equally employed. In tracing the commonest object, a plant or the stump of a tree, you learn something every moment. You perceive unexpected differences, and discover likenesses where you looked for no such thing. You try to set down what you see – find out your error, and correct it. You need not play tricks, or purposely mistake: with all your pains, you are still far short of the mark. Patience grows out of the endless pursuit, and turns it into a luxury. A streak in a flower, a wrinkle in a leaf, a tinge in a cloud, a stain in an old wall or ruin grey, are seized with avidity as the *spolia opima*[11] of this sort of mental warfare, and furnish out labour for another half-day. The hours pass away untold, without chagrin, and without weariness; nor would you ever wish to pass them otherwise. Innocence is joined with industry, pleasure with business; and

the mind is satisfied, though it is not engaged in thinking or in doing any mischief.*

I have not much pleasure in writing these *Essays*, or in reading them afterwards; though I own I now and then meet with a phrase that I like, or a thought that strikes me as a true one. But after I begin them, I am only anxious to get to the end of them, which I am not sure I shall do, for I seldom see my way a page or even a sentence beforehand; and when I have as by a miracle escaped, I trouble myself little more about them. I sometimes have to write them twice over: then it is necessary to read the *proof*, to prevent mistakes by the printer; so that by the time they appear in a tangible shape, and one can con them over with a conscious, sidelong glance to the public approbation, they have lost their gloss and relish, and become 'more tedious than

* There is a passage in Werter which contains a very pleasing illustration of this doctrine, and is as follows:

'About a league from the town is a place called Walheim. It is very agreeably situated on the side of a hill: from one of the paths which leads out of the village, you have a view of the whole country; and there to a good old woman who sells wine, coffee, and tea there: but better than all this are two lime trees before the church, which spread their branches over a little green, surrounded by barns and cottages. I have seen few places more retired and peaceful. I send for a chair and table from the old woman's, and there I drink my coffee and read Homer. It was by accident that I discovered this place one fine afternoon: all was perfect stillness; everybody was in the fields, except a little boy about four years old, who was sitting on the ground, and holding between his knees a child of about six months; he pressed it to his bosom with his little arms, which made a sort of great chair for it; and notwithstanding the vivacity which sparkled in his eyes, he sat perfectly still. Quite delighted with the scene, I sat down on a plough opposite, and had great pleasure in drawing this little picture of brotherly tenderness. I added a bit of the hedge, the barn door, and some broken cartwheels, without any order, just as they happened to lie; and in about an hour I found I had made a drawing of great expression and very correct design without having put in anything of my own. This confirmed me in the resolution I had made before, only to copy Nature for the future. Nature is inexhaustible, and alone forms the greatest masters. Say what you will of rules, they alter the true features and the natural expression.'

a twice-told tale'. For a person to read his own works over with any great delight, he ought first to forget that he ever wrote them. Familiarity naturally breeds contempt. It is, in fact, like poring fondly over a piece of blank paper; from repetition, the words convey no distinct meaning to the mind, are mere idle sounds, except that our vanity claims an interest and property in them. I have more satisfaction in my own thoughts than in dictating them to others: words are necessary to explain the impression of certain things upon me to the reader, but they rather weaken and draw a veil over than strengthen it to myself. However I might say with the poet, 'My mind to me a kingdom is,' yet I have little ambition 'to set a throne or chair of state in the understandings of other men.' The ideas we cherish most exist best in a kind of shadowy abstraction, 'Pure in the last recesses of the mind,'[12] and derive neither force nor interest from being exposed to public view. They are old familiar acquaintance, and any change in them, arising from the adventitious ornaments of style or dress, is little to their advantage. After I have once written on a subject, it goes out of my mind: my feelings about it have been melted down into words, and *then* I forget. I have, as it were, discharged my memory of its old habitual reckoning, and rubbed out the score of real sentiment. For the future it exists only for the sake of others. But I cannot say, from my own experience, that the same process takes place in transferring our ideas to canvas; they gain more than they lose in the mechanical transformation. One is never tired of painting, because you have to set down not what you knew already, but what you have just discovered. In the former case you translate feelings into words; in the latter, names into things. There is a continual creation out of nothing going on. With every stroke of the brush a new field of inquiry is laid open; new difficulties arise, and new triumphs are prepared over them. By comparing the imitation with the original, you see what you have done, and how much you have still to do. The test of the senses is severer than that of fancy, and an over-match even for the delusions of

our self-love. One part of a picture shames another, and you determine to paint up to yourself, if you cannot come up to nature. Every object becomes lustrous from the light thrown back upon it by the mirror of art: and by the aid of the pencil we may be said to touch and handle the objects of sight. The air-drawn visions that hover on the verge of existence have a bodily presence given them on the canvas: the form of beauty is changed into a substance: the dream and the glory of the universe is made 'palpable to feeling as well as sight.' – And see! a rainbow starts from the canvas, with its humid train of glory, as if it were drawn from its cloudy arch in heaven. The spangled landscape glitters with drops of dew after the shower. The 'fleecy fools' show their coats in the gleams of the setting sun. The shepherds pipe their farewell notes in the fresh evening air. And is this bright vision made from a dead, dull blank, like a bubble reflecting the mighty fabric of the universe? Who would think this miracle of Rubens' pencil possible to be performed? Who, having seen it, would not spend his life to do the like? See how the rich fallows, the bare stubble-field, the scanty harvest-home, drag in Rembrandt's landscapes! How often have I looked at them and nature, and tried to do the same, till the very 'light thickened', and there was an earthiness in the feeling of the air! There is no end of the refinements of art and nature in this respect. One may look at the misty glimmering horizon till the eye dazzles and the imagination is lost, in hopes to transfer the whole interminable expanse at one blow upon the canvas. Wilson said, he used to try to paint the effect of the motes dancing in the setting sun. At another time, a friend, coming into his painting room when he was sitting on the ground in a melancholy posture, observed that his picture looked like a landscape after a shower: he started up with the greatest delight, and said, 'That is the effect I intended to produce, but thought I had failed.' Wilson was neglected; and, by degrees, neglected his art to apply himself to brandy. His hand became unsteady, so that it was only by repeated attempts

that he could reach the place or produce the effect he aimed at; and when he had done a little to a picture, he would say to any acquaintance who chanced to drop in, 'I have painted enough for one day: come, let us go somewhere.' It was not so Claude left his pictures, or his studies on the banks of the Tiber, to go in search of other enjoyments, or ceased to gaze upon the glittering sunny vales and distant hills; and while his eye drank in the clear sparkling hues and lovely forms of nature, his hand stamped them on the lucid canvas to last there for ever! One of the most delightful parts of my life was one fine summer, when I used to walk out of an evening to catch the last light of the sun, gemming the green slopes or russet lawns, and gilding tower or tree, while the blue sky, gradually turning to purple and gold, or skirted with dusky grey, hung its broad marble pavement over all, as we see it in the great master of Italian landscape. But to come to a more particular explanation of the subject.

The first head I ever tried to paint was an old woman with the upper part of the face shaded by her bonnet, and I certainly laboured it with great perseverance. It took me numberless sittings to do it. I have it by me still, and sometimes look at it with surprise, to think how much pains were thrown away to little purpose, – yet not altogether in vain if it taught me to see good in everything, and to know that there is nothing vulgar in nature seen with the eye of science or of true art. Refinement creates beauty everywhere: it is the grossness of the spectator that discovers nothing but grossness in the object. Be this as it may, I spared no pains to do my best. If art was long, I thought that life was so too at that moment. I got in the general effect the first day; and pleased and surprised enough I was at my success. The rest was a work of time – of weeks and months (if need were), of patient toil and careful finishing. I had seen an old head by Rembrandt at Burleigh House, and if I could produce a head at all like Rembrandt in a year, in my lifetime, it would be glory and felicity and wealth

and fame enough for me! The head I had seen at Burleigh was an exact and wonderful facsimile of nature, and I resolved to make mine (as nearly as I could) an exact facsimile of nature. I did not then, nor do I now believe, with Sir Joshua, that the perfection of art consists in giving general appearances without individual details, but in giving general appearances with individual details. Otherwise, I had done my work the first day.

But I saw something more in nature than general effect, and I thought it worth my while to give it in the picture. There was a gorgeous effect of light and shade; but there was a delicacy as well as depth in the chiaroscuro which I was bound to follow into its dim and scarce perceptible variety of tone and shadow. Then I had to make the transition from a strong light to as dark a shade, preserving the masses, but gradually softening off the intermediate parts. It was so in nature; the difficulty was to make it so in the copy. I tried, and failed again and again; I strove harder, and succeeded as I thought. The wrinkles in Rembrandt were not hard lines, but broken and irregular. I saw the same appearance in nature, and strained every nerve to give it. If I could hit off this edgy appearance, and insert the reflected light in the furrows of old age in half a morning, I did not think I had lost a day. Beneath the shrivelled yellow parchment look of the skin, there was here and there a streak of the blood colour tinging the face; this I made a point of conveying, and did not cease to compare what I saw with what I did (with jealous, lynx-eyed watchfulness) till I succeeded to the best of my ability and judgement. How many revisions were there! How many attempts to catch an expression which I had seen the day before! How often did we try to get the old position, and wait for the return of the same light! There was a puckering up of the lips, a cautious introversion of the eye under the shadow of the bonnet, indicative of the feebleness and suspicion of old age, which at last we managed, after many trials and some quarrels, to a tolerable nicety. The picture was never finished, and I might have gone on with it to the present

hour.* I used to sit it on the ground when my day's work was done, and saw revealed to me with swimming eyes the birth of new hopes and of a new world of objects. The painter thus learns to look at nature with different eyes. He before saw her 'as in a glass darkly, but now face to face.' He understands the texture and meaning of the visible universe, and 'sees into the life of things', not by the help of mechanical instruments, but of the improved exercise of his faculties, and an intimate sympathy with nature. The meanest thing is not lost upon him, for he looks at it with an eye to itself, not merely to his own vanity or interest, or the opinion of the world. Even where there is neither beauty nor use – if that ever were – still there is truth, and a sufficient source of gratification in the indulgence of curiosity and activity of mind. The humblest printer is a true scholar; and the best of scholars – the scholar of nature. For myself, and for the real comfort and satisfaction of the thing, I had rather have been Jan Steen, or Gerard Dow, than the greatest casuist or philologer that ever lived. The painter does not view things in clouds or 'mist, the common gloss of theologians,' but applies the same standard of truth and disinterested spirit of inquiry, that influence his daily practice, to other subjects. He perceives form, he distinguishes character. He reads men and books with an intuitive eye. He is a critic as well as a connoisseur. The conclusions he draws are clear and convincing, because they are taken from the things themselves. He is not a fanatic, a dupe, or a slave; for the habit of seeing for himself also disposes him to judge for himself. The most sensible men I know (taken as a class) are painters; that is, they are the most lively observers of what passes in the world about them, and the closest observers of what passes in their own minds. From their profession they in general mix

* It is at present covered with a thick slough of oil and varnish (the perishable vehicle of the English school), like an envelope of goldbeaters' skin, so as to be hardly visible.

more with the world than authors; and if they have not the same fund of acquired knowledge, are obliged to rely more on individual sagacity. I might mention the names of Opie, Fuseli, Northcote, as persons distinguished for striking description and acquaintance with the subtle traits of character.* Painters in ordinary society, or in obscure situations where their value is not known, and they are treated with neglect and indifference, have sometimes a forward self-sufficiency of manner; but this is not so much their fault as that of others. Perhaps their want of regular education may also be in fault in such cases. Richardson, who is very tenacious of the respect in which the profession ought to be held, tells a story of Michael Angelo, that after a quarrel between him and Pope Julius II, 'upon account of a slight the artist conceived the pontiff had put upon him, Michael Angelo was introduced by a bishop, who, thinking to serve the artist by it, made it an argument that the Pope should be reconciled to him, because men of his profession were commonly ignorant, and of no consequence otherwise; his holiness, enraged at the bishop, struck him with his staff, and told him, it was he that was the blockhead, and affronted the man himself would not offend: the prelate was driven out of the chamber, and Michael Angelo had the Pope's benediction, accompanied with presents. This bishop had fallen into the vulgar error, and was rebuked accordingly.'

Besides the exercise of the mind, painting exercises the body. It is a mechanical as well as a liberal art. To do anything, to dig a hole in the ground, to plant a cabbage, to hit a mark, to move a shuttle, to work a pattern, – in a word, to attempt to produce

* Men in business, who are answerable with their fortunes for the consequences of their opinions, and are therefore accustomed to ascertain pretty accurately the grounds on which they act, before they commit themselves on the event, are often men of remarkably quick and sound judgements. Artists in like manner must know tolerably well what they are about, before they can bring the result of their observations to the test of ocular demonstration.

any effect, and to *succeed*, has something in it that gratifies the love of power, and carries off the restless activity of the mind of man. Indolence is a delightful but distressing state; we must be doing something to be happy. Action is no less necessary than thought to the instinctive tendencies of the human frame; and painting combines them both incessantly.* The hand is furnished a practical test of the correctness of the eye; and the eye, thus admonished, imposes fresh tasks of skill and industry upon the hand. Every stroke tells as the verifying of a new truth; and every new observation, the instant it is made, passes into an act and emanation of the will. Every step is nearer what we wish, and yet there is always more to do. In spite of the facility, the fluttering grace, the evanescent hues, that play round the pencil of Rubens and Vandyke, however I may admire, I do not envy them this power so much as I do the slow, patient, laborious execution of Correggio, Leonardo da Vinci, and Andrea del Sarto, where every touch appears conscious of its charge, emulous of truth, and where the painful artist has so distinctly wrought: 'That you might almost say his picture thought!'[13]

In the one case the colours seem breathed on the canvas as if by magic, the work and the wonder of a moment; in the other they seem inlaid in the body of the work, and as if it took the artist years of unremitting labour, and of delightful never-ending progress to perfection.† Who would wish ever to come to the close of such works, – not to dwell on them, to return to them, to be wedded to them to the last? Rubens, with his florid, rapid style, complains that when he had just learned his art, he should be forced to die. Leonardo, in the slow advances of his, had lived long enough!

* The famous Schiller used to say, that he found the great happiness of life, after all, to consist in the discharge of some mechanical duty.
† The rich *impasting* of Titian and Giorgione combines something of the advantages of both these styles, the felicity of the one with the carefulness of the other, and is perhaps to be preferred to either.

Painting is not, like writing, what is properly understood by a sedentary employment. It requires not indeed a strong, but a continued and steady exertion of muscular power. The precision and delicacy of the manual operation, makes up for the want of vehemence, – as to balance himself for any time in the same position the rope-dancer must strain every nerve. Painting for a whole morning gives one as excellent an appetite for one's dinner as old Abraham Tucker acquired for his by riding over Banstead Downs. It is related of Sir Joshua Reynolds, that 'he took no other exercise than what he used in his painting room', – the writer means, in walking backwards and forwards to look at his picture; but the act of painting itself, of laying on the colours in the proper place and proper quantity, was a much harder exercise than this alternate receding from and returning to the picture. This last would be rather a relaxation and relief than an effort. It is not to be wondered at, that an artist like Sir Joshua, who delighted so much in the sensual and practical part of his art, should have found himself at a considerable loss when the decay of his sight precluded him, for the last year or two of his life, from the following up of his profession, – 'the source', according to his own remark, 'of thirty years' uninterrupted enjoyment and prosperity to him'. It is only those who never think at all, or else who have accustomed themselves to brood incessantly on abstract ideas, that never feel ennui.

To give one instance more, and then I will have done with this rambling discourse. One of my first attempts was a picture of my father, who was then in a green old age, with strong-marked features, and scarred with the smallpox. I drew it out with a broad light crossing the face, looking down, with spectacles on, reading. The book was Shaftesbury's *Characteristics*, in a fine old binding, with Gribelin's etchings. My father would as lieve it had been any other book; but for him to read was to be content, was 'riches fineless'. The sketch promised well; and I set to work to finish it, determined to spare no time nor pains. My father was willing to sit as long as I pleased; for there is

a natural desire in the mind of man to sit for one's picture, to be the object of continued attention, to have one's likeness multiplied; and besides his satisfaction in the picture, he had some pride in the artist, though he would rather I should have written a sermon than painted like Rembrandt or like Raphael. Those winter days, with the gleams of sunshine coming through the chapel windows, and cheered by the notes of the robin redbreast in our garden (that 'ever in the haunch of winter sings') – as my afternoon's work drew to a close, – were among the happiest of my life. When I gave the effect I intended to any part of the picture for which I had prepared my colours; when I imitated the roughness of the skin by a lucky stroke of the pencil; when I hit the clear, pearly tone of a vein; when I gave the ruddy complexion of health, the blood circulating under the broad shadows of one side of the face, I thought my fortune made; or rather it was already more than made, I might one day be able to say with Correggio, '*I also am a painter!*' It was an idle thought, a boy's conceit; but it did not make me less happy at the time. I used regularly to set my work in the chair to look at it through the long evenings; and many a time did I return to take leave of it before I could go to bed at night. I remember sending it with a throbbing heart to the Exhibition, and seeing it hung up there by the side of one of the Honourable Mr Skeffington (now Sir George). There was nothing in common between them, but that they were the portraits of two very good-natured men. I think, but am not sure, that I finished this portrait (or another afterwards) on the same day that the news of the battle of Austerlitz came; I walked out in the afternoon, and, as I returned, saw the evening star set over a poor man's cottage with other thoughts and feelings than I shall ever have again. Oh for the revolution of the great Platonic year, that those times might come over again! I could sleep out the three hundred and sixty-five thousand intervening years very contentedly! – The picture is left: the table, the chair, the window where I learned to construe

Livy, the chapel where my father preached, remain where they were; but he himself is gone to rest, full of years, of faith, of hope, and charity!

First published in the *London Magazine*, 1820.

The Same Subject Continued

The painter not only takes a delight in nature, he has a new and exquisite source of pleasure opened to him in the study and contemplation of works of art –

> Whate'er Lorraine light touch'd with soft'ning hue,
> Or savage Rosa dash'd, or learned Poussin drew.[14]

He turns aside to view a country gentleman's seat with eager looks, thinking it may contain some of the rich products of art. There is an air round Lord Radnor's park, for there hang the two Claudes, the Morning and Evening of the Roman Empire – round Wilton House, for there is Vandyke's picture of the Pembroke family – round Blenheim, for there is his picture of the Duke of Buckingham's children, and the most magnificent collection of Rubenses in the world – at Knowsley, for there is Rembrandt's Handwriting on the Wall – and at Burleigh, for there are some of Guido's angelic heads. The young artist makes a pilgrimage to each of these places, eyes them wistfully at a distance, 'bosomed high in tufted trees', and feels an interest in them of which the owner is scarce conscious: he enters the well-swept walks and echoing archways, passes the threshold, is led through wainscoted rooms, is shown the furniture, the rich hangings, the tapestry, the massy services of plate – and, at last, is ushered into the room where his treasure is, the idol of his vows – some speaking face or bright landscape! It is stamped on his brain, and lives there thenceforward, a tally for nature, and a test of art. He furnishes out the chambers of the mind from the spoils of time, picks and chooses which shall have the best places – nearest his heart. He goes away richer than he came, richer than the possessor; and thinks that he may one day return, when he perhaps shall have done something like them, or even from failure shall have learned to admire truth and genius more.

My first initiation in the mysteries of the art was at the Orleans Gallery: it was there I formed my taste, such as it is; so that I am irreclaimably of the old school in painting. I was staggered when I saw the works there collected, and looked at them with wondering and with longing eyes. A mist passed away from my sight: the scales fell off. A new sense came upon me, a new heaven and a new earth stood before me. I saw the soul speaking in the face – 'hands that the rod of empire had swayed' in mighty ages past – 'a forked mountain or blue promontory',

> – with trees upon't
> That nod unto the world, and mock our eyes with air.[15]

Old Time had unlocked his treasures, and Fame stood portress at the door. We had all heard of the names of Titian, Raphael, Guido, Domenichino, the Caracci – but to see them face to face, to be in the same room with their deathless productions, was like breaking some mighty spell – was almost an effect of necromancy! From that time I lived in a world of pictures. Battles, sieges, speeches in parliament seemed mere idle noise and fury, 'signifying nothing', compared with those mighty works and dreaded names that spoke to me in the eternal silence of thought. This was the more remarkable, as it was but a short time before that I was not only totally ignorant of, but insensible to the beauties of art. As an instance, I remember that one afternoon I was reading *The Provoked Husband* with the highest relish, with a green woody landscape of Ruysdael or Hobbema just before me, at which I looked off the book now and then, and wondered what there could be in that sort of work to satisfy or delight the mind – at the same time asking myself, as a speculative question, whether I should ever feel an interest in it like what I took in reading Vanbrugh and Cibber?

I had made some progress in painting when I went to the Louvre to study, and I never did anything afterwards. I never

shall forget conning over the Catalogue which a friend lent me just before I set out. The pictures, the names of the painters, seemed to relish in the mouth. There was one of Titian's Mistress at her toilette. Even the colours with which the painter had adorned her hair were not more golden, more amiable to sight, than those which played round and tantalised my fancy ere I saw the picture. There were two portraits by the same hand – 'A young Nobleman with a glove' – Another, 'a companion to it'. I read the description over and over with fond expectancy, and filled up the imaginary outline with whatever I could conceive of grace, and dignity, and an antique *gusto* – all but equal to the original. There was the Transfiguration too. With what awe I saw it in my mind's eye, and was overshadowed with the spirit of the artist! Not to have been disappointed with these works afterwards, was the highest compliment I can pay to their transcendent merits. Indeed, it was from seeing other works of the same great masters that I had formed a vague, but not disparaging idea of these. The first day I got there, I was kept for some time in the French Exhibition Room, and thought I should not be able to get a sight of the old masters. I just caught a peep at them through the door (vile hindrance!) like looking out of purgatory into paradise – from Poussin's noble, mellow-looking landscapes to where Rubens hung out his gaudy banner, and down the glimmering vista to the rich jewels of Titian and the Italian school. At last, by much importunity, I was admitted, and lost not an instant in making use of my new privilege. It was *un beau jour* to me. I marched delighted through a quarter of a mile of the proudest efforts of the mind of man, a whole creation of genius, a universe of art! I ran the gauntlet of all the schools from the bottom to the top; and in the end got admitted into the inner room, where they had been repairing some of their greatest works. Here the *Transfiguration*, the *St Peter Martyr*, and the *St Jerome of Domenichino* stood on the floor, as if they had bent their knees, like camels stooping, to unlade their riches to the spectator.

On one side, on an easel, stood Hippolito de Medici (a portrait by Titian), with a boar spear in his hand, looking through those he saw, till you turned away from the keen glance; and thrown together in heaps were landscapes of the same hand, green pastoral hills and vales, and shepherds piping to their mild mistresses underneath the flowering shade. Reader, 'if thou hast not seen the Louvre thou art damned!' – for thou hast not seen the choicest remains of the works of art; or thou hast not seen all these together with their mutually reflected glories. I say nothing of the statues; for I know but little of sculpture, and never liked any till I saw the Elgin Marbles... Here, for four months together, I strolled and studied, and daily heard the warning sound – '*Quatres heures passées, il faut fermer, Citoyens*'[16] – (Ah! why did they ever change their style?) muttered in coarse provincial French; and brought away with me some loose draughts and fragments, which I have been forced to part with, like drops of life-blood, for 'hard money'. How often, thou tenantless mansion of godlike magnificence – how often has my heart since gone a pilgrimage to thee!

It has been made a question, whether the artist, or the mere man of taste and natural sensibility, receives most pleasure from the contemplation of works of art; and I think this question might be answered by another as a sort of *experimentum crucis*, namely, whether any one out of that 'number numberless' of mere gentlemen and amateurs, who visited Paris at the period here spoken of, felt as much interest, as much pride or pleasure in this display of the most striking monuments of art as the humblest student would? The first entrance into the Louvre would be only one of the events of his journey, not an event in his life, remembered ever after with thankfulness and regret. He would explore it with the same unmeaning curiosity and idle wonder as he would the Regalia in the Tower, or the Botanic Garden in the Tuileries, but not with the fond enthusiasm of an artist. How should he? His is 'casual fruition, joyless, unendeared'. But the painter is wedded to his art – the

mistress, queen, and idol of his soul. He has embarked his all in it, fame, time, fortune, peace of mind – his hopes in youth, his consolation in age: and shall he not feel a more intense interest in whatever relates to it than the mere indolent trifler? Natural sensibility alone, without the entire application of the mind to that one object, will not enable the possessor to sympathise with all the degrees of beauty and power in the conceptions of a Titian or a Correggio; but it is he only who does this, who follows them into all their force and matchless race, that does or can feel their full value. Knowledge is pleasure as well as power. No one but the artist who has studied nature and contended with the difficulties of art, can be aware of the beauties, or intoxicated with a passion for painting. No one who has not devoted his life and soul to the pursuit of art can feel the same exultation in its brightest ornaments and loftiest triumphs which an artist does. Where the treasure is, there the heart is also. It is now seventeen years since I was studying in the Louvre (and I have long since given up all thoughts of the art as a profession), but long after I returned, and even still, I sometimes dream of being there again – of asking for the old pictures – and not finding them, or finding them changed or faded from what they were, I cry myself awake! What gentleman-amateur ever does this at such a distance of time, – that is, ever received pleasure or took interest enough in them to produce so lasting an impression?

But it is said that if a person had the same natural taste, and the same acquired knowledge as an artist, without the petty interests and technical notions, he would derive a purer pleasure from seeing a fine portrait, a fine landscape, and so on. This, however, is not so much begging the question as asking an impossibility: he cannot have the same insight into the end without having studied the means; nor the same love of art without the same habitual and exclusive attachment to it. Painters are, no doubt, often actuated by jealousy, partiality and a sordid attention to that only which they find useful to

themselves in painting. W— has been seen poring over the texture of a Dutch cabinet-picture, so that he could not see the picture itself. But this is the perversion and pedantry of the profession, not its true or genuine spirit. If W— had never looked at anything but megilps and handling, he never would have put the soul of life and manners into his pictures, as he has done. Another objection is, that the instrumental parts of the art, the means, the first rudiments, paints, oils, and brushes, are painful and disgusting; and that the consciousness of the difficulty and anxiety with which perfection has been attained must take away from the pleasure of the finest performance. This, however, is only an additional proof of the greater pleasure derived by the artist from his profession; for these things which are said to interfere with and destroy the common interest in works of art do not disturb him; he never once thinks of them, he is absorbed in the pursuit of a higher object; he is intent, not on the means, but the end; he is taken up, not with the difficulties, but with the triumph over them. As in the case of the anatomist, who overlooks many things in the eagerness of his search after abstract truth; or the alchemist who, while he is raking into his soot and furnaces, lives in a golden dream; a lesser gives way to a greater object. But it is pretended that the painter may be supposed to submit to the unpleasant part of the process only for the sake of the fame or profit in view. So far is this from being a true state of the case, that I will venture to say, in the instance of a friend of mine who has lately succeeded in an important undertaking in his art, that not all the fame he has acquired, not all the money he has received from thousands of admiring spectators, not all the newspaper puffs, – nor even the praise of the *Edinburgh Review*, – not all these put together ever gave him at any time the same genuine, undoubted satisfaction as any one half-hour employed in the ardent and propitious pursuit of his art – in finishing to his heart's content a foot, a hand, or even a piece of drapery. What is the state of mind of an artist while he is at work? He is then in the act of realising

the highest idea he can form of beauty or grandeur: he conceives, he embodies that which he understands and loves best: that is, he is in full and perfect possession of that which is to him the source of the highest happiness and intellectual excitement which he can enjoy.

In short, as a conclusion to this argument, I will mention a circumstance which fell under my knowledge the other day. A friend had bought a print of Titian's Mistress, the same to which I have alluded above. He was anxious to show it me on this account. I told him it was a spirited engraving, but it had not the look of the original. I believe he thought this fastidious, till I offered to show him a rough sketch of it, which I had by me. Having seen this, he said he perceived exactly what I meant, and could not bear to look at the print afterwards. He had good sense enough to see the difference in the individual instance; but a person better acquainted with Titian's manner and with art in general – that is, of a more cultivated and refined taste – would know that it was a bad print, without having any immediate model to compare it with. He would perceive with a glance of the eye, with a sort of instinctive feeling, that it was hard, and without that bland, expansive, and nameless expression which always distinguished Titian's most famous works. Anyone who is accustomed to a head in a picture can never reconcile himself to a print from it; but to the ignorant they are both the same. To a vulgar eye there is no difference between a Guido and a daub – between a penny print, or the vilest scrawl, and the most finished performance. In other words, all that excellence which lies between these two extremes, – all, at least, that marks the excess above mediocrity, – all that constitutes true beauty, harmony, refinement, grandeur, is lost upon the common observer. But it is from this point that the delight, the glowing raptures of the true adept commence. An uninformed spectator may like an ordinary drawing better than the ablest connoisseur; but for that very reason he cannot like the highest specimens of art so well. The refinements not only

of execution but of truth and nature are inaccessible to un-practised eyes. The exquisite gradations in a sky of Claude's are not perceived by such persons, and consequently the harmony cannot be felt. Where there is no conscious apprehension, there can be no conscious pleasure. Wonder at the first sights of works of art may be the effect of ignorance and novelty; but real admiration and permanent delight in them are the growth of taste and knowledge. 'I would not wish to have your eyes,' said a good-natured man to a critic who was finding fault with a picture in which the other saw no blemish. Why so? The idea which prevented him from admiring this inferior production was a higher idea of truth and beauty which was ever present with him, and a continual source of pleasing and lofty contem-plations. It may be different in a taste for outward luxuries and the privations of mere sense; but the idea of perfection, which acts as an intellectual foil, is always an addition, a support, and a proud consolation!

Richardson, in his *Essays*, which ought to be better known, has left some striking examples of the felicity and infelicity of artists, both as it relates to their external fortune and to the practice of their art. In speaking of *the knowledge of hands*, he exclaims: 'When one is considering a picture or a drawing, one at the same time thinks this was done by him* who had many extraordinary endowments of body and mind, but was withal very capricious; who was honoured in life and death, expiring in the arms of one of the greatest princes of that age, Francis I, King of France, who loved him as a friend. Another is of him† who lived a long and happy life, beloved of Charles V, emperor; and many others of the first princes of Europe. When one has another in hand, we think this was done by one‡ who so excelled in three arts, as that any of them in that degree had

* Leonardo da Vinci.
† Titian.
‡ Michael Angelo.

rendered him worthy of immortality; and one moreover that durst contend with his sovereign (one of the haughtiest Popes that ever was) upon a slight offered to him, and extricated himself with honour. Another is the work of him* who, without any one exterior advantage but mere strength of genius, had the most sublime imaginations, and executed them accordingly, yet lived and died obscurely. Another we shall consider as the work of him† who restored Painting when it had almost sunk; of him whom art made honourable, but who, neglecting and despising greatness with a sort of cynical pride, was treated suitably to the figure he gave himself, not his intrinsic worth; which, not having philosophy enough to bear it, broke his heart. Another is done by one‡ who (on the contrary) was a fine gentleman and lived in great magnificence, and was much honoured by his own and foreign princes; who was a courtier, a statesman, and a painter; and so much all these, that when he acted in either character, *that* seemed to be his business, and the others his diversion. I say when one thus reflects, besides the pleasure arising from the beauties and excellences of the work, the fine ideas it gives us of natural things, the noble way of thinking it suggest to us, an additional pleasure results from the above considerations. But, oh! the pleasure, when a connoisseur and lover of art has before him a picture or drawing of which he can say this is the hand, these are the thoughts of him§ who was one of the politest, best-natured gentlemen that ever was; and beloved and assisted by the greatest wits and the greatest men then in Rome: of him who lived in great fame, honour, and magnificence, and died extremely lamented; and missed a Cardinal's hat only by dying a few months too soon; but was particularly esteemed and favoured by two Popes, the only ones

* Correggio.
† Annibale Caracci.
‡ Rubens.
§ Raphael.

who filled the chair of St Peter in his time, and as great men as ever sat there since that apostle, if at least he ever did: one, in short, who could have been a Leonardo, a Michael Angelo, a Titian, a Correggio, a Parmegiano, an Annibal, a Rubens, or any other whom he pleased, but none of them could ever have been a Raphael.'

The same writer speaks feelingly of the change in the style of different artists from their change of fortune, and as the circumstances are little known I will quote the passage relating to two of them.

'Guido Reni, from a prince-like affluence of fortune (the just reward of his angelic works), fell to a condition like that of a hired servant to one who supplied him with money for what he did at a fixed rate; and that by his being bewitched by a passion for gaming, whereby he lost vast sums of money; and even what he got in his state of servitude by day, he commonly lost at night: nor could he ever be cured of this cursed madness. Those of his works, therefore, which he did in this unhappy part of his life may easily be conceived to be in a different style to what he did before, which in some things, that is, in the airs of his heads (in the gracious kind) had a delicacy in them peculiar to himself, and almost more than human. But I must not multiply instances. Parmegiano is one that alone takes in all the several kinds of variation, and all the degrees of goodness, from the lowest of the indifferent up to the sublime. I can produce evident proofs of this in so easy a gradation, that one cannot deny but that he that did this might do that, and very probably did so; and thus one may ascend and descend, like the angels on Jacob's ladder, whose foot was upon the earth, but its top reached to Heaven.

'And this great man had his unlucky circumstance: he became mad after the philosopher's stone, and did but very little in painting or drawing afterwards. Judge what that was, and whether there was not an alteration of style from what he had done before this devil possessed him. His creditors

endeavoured to exorcise him, and did him some good, for he set himself to work again in his own way; but if a drawing I have of a Lucretia be that he made for his last picture, as it probably is (Vasari says that was the subject of it), it is an evident proof of his decay; it is good indeed, but it wants much of the delicacy which is commonly seen in his works; and so I always thought before I knew or imagined it to be done in this his ebb of genius.'

We have had two artists of our own country whose fate has been as singular as it was hard: Gandy was a portrait painter in the beginning of the last century, whose heads were said to have come near to Rembrandt's, and he was the undoubted prototype of Sir Joshua Reynolds' style. Yet his name has scarcely been heard of; and his reputation, like his works, never extended beyond his own country. What did he think of himself and of a fame so bounded? Did he ever dream he was indeed an artist? Or how did this feeling in him differ from the vulgar conceit of the lowest pretender? The best known of his works is a portrait of an alderman of Exeter, in some public building in that city.

Poor Dan Stringer! Forty years ago he had the finest hand and the clearest eye of any artist of his time, and produced heads and drawings that would not have disgraced a brighter period in the art. But he fell a martyr (like Burns) to the society of country gentlemen, and then of those whom they would consider as more his equals. I saw him many years ago when he treated the masterly sketches he had by him (one in particular of the group of citizens in Shakespeare 'swallowing the tailor's news') as 'bastards of his genius, not his children', and seemed to have given up all thoughts of his art. Whether he is since dead, I cannot say; the world do not so much as know that he ever lived!

First published in the *London Magazine*, 1820.

On a Landscape of Nicolas Poussin

And blind Orion hungry for the morn.[17]

Orion, the subject of this landscape, was the classical Nimrod; and is called by Homer, 'a hunter of shadows, himself a shade'. He was the son of Neptune; and having lost an eye in some affray between the Gods and men, was told that if he would go to meet the rising sun he would recover his sight. He is represented setting out on his journey, with men on his shoulders to guide him, a bow in his hand, and Diana in the clouds greeting him. He stalks along, a giant upon earth, and reels and falters in his gait, as if just awakened out of sleep, or uncertain of his way; – you see his blindness, though his back is turned. Mists rise around him, and veil the sides of the green forests; earth is dank and fresh with dews, the 'grey dawn and the Pleiades before him dance', and in the distance are seen the blue hills and sullen ocean. Nothing was ever more finely conceived or done. It breathes the spirit of the morning; its moisture, its repose, its obscurity, waiting the miracle of light to kindle it into smiles; the whole is, like the principal figure in it, 'a forerunner of the dawn'. The same atmosphere tinges and imbues every object, the same dull light 'shadowy sets off' the face of nature: one feeling of vastness, of strangeness, and of primeval forms pervades the painter's canvas, and we are thrown back upon the first integrity of things. This great and learned man might be said to see nature through the glass of time; he alone has a right to be considered as the painter of classical antiquity. Sir Joshua has done him justice in this respect. He could give to the scenery of his heroic fables that unimpaired look of original nature, full, solid, large, luxuriant, teeming with life and power; or deck it with all the pomp of art, with temples and towers, and mythologic groves. His pictures 'denote a foregone conclusion'. He applies nature to his purposes, works out her images

according to the standard of his thoughts, embodies high fictions; and the first conception being given, all the rest seems to grow out of and be assimilated to it, by the unfailing process of a studious imagination. Like his own Orion, he overlooks the surrounding scene, appears to 'take up the isles as a very little thing, and to lay the earth in a balance'. With a laborious and mighty grasp, he puts nature into the mould of the ideal and antique; and was among painters (more than anyone else) what Milton was among poets. There is in both something of the same pedantry, the same stiffness, the same elevation, the same grandeur, the same mixture of art and nature, the same richness of borrowed materials, the same unity of character. Neither the poet nor the painter lowered the subjects they treated, but filled up the outline in the fancy, and added strength and reality to it; and thus not only satisfied, but surpassed the expectations of the spectator and the reader. This is held for the triumph and the perfection of works of art. To give us nature, such as we see it, is well and deserving of praise; to give us nature, such as we have never seen, but have often wished to see it, is better, and deserving of higher praise. He who can show the world in its first naked glory, with the hues of fancy spread over it, or in its high and palmy state, with the gravity of history stamped on the proud monuments of vanished empire, – who, by his 'so potent art', can recall time past, transport us to distant places, and join the regions of imagination (a new conquest) to those of reality – who shows us not only what nature is, but what she has been, and is capable of – he who does this, and does it with simplicity, with truth, and grandeur, is lord of nature and her powers; and his mind is universal, and his art the master-art!

There is nothing in this 'more than natural', if criticism could be persuaded to think so. The historic painter does not neglect or contravene nature, but follows her more closely up into her fantastic heights or hidden recesses. He demonstrates what she would be in conceivable circumstances and under implied conditions. He 'gives to airy nothing a local habitation', not 'a name'.

At his touch, words start up into images, thoughts become things. He clothes a dream, a phantom, with form and colour, and the wholesome attributes of reality. *His* art is a second nature; not a different one. There are those, indeed, who think that not to copy nature is the rule for attaining perfection. Because they cannot paint the objects which they have seen, they fancy themselves qualified to paint the ideas which they have not seen. But it is possible to fail in this latter and more difficult style of imitation, as well as in the former humbler one. The detection, it is true, is not so easy, because the objects are not so nigh at hand to compare, and therefore there is more room both for false pretension and for self-deceit. They take an epic motto or subject, and conclude that the spirit is implied as a thing of course. They paint inferior portraits, maudlin lifeless faces, without ordinary expression, or one look, feature, or particle of nature in them, and think that this is to rise to the truth of history. They vulgarise and degrade whatever is interesting or sacred to the mind, and suppose that they thus add to the dignity of their profession. They represent a face that seems as if no thought or feeling of any kind had ever passed through it, and would have you believe that this is the very sublime of expression, such as it would appear in heroes, or demigods of old, when rapture or agony was raised to its height. They show you a landscape that looks as if the sun never shone upon it, and tell you that it is not modern – that so earth looked when Titan first kissed it with his rays. This is not the true *ideal*. It is not to fill the moulds of the imagination, but to deface and injure them; it is not to come up to, but to fall short of the poorest conception in the public mind. Such pictures should not be hung in the same room with that of Orion.*

* Everything tends to show the manner in which a great artist is formed. If any person could claim an exemption from the careful imitation of individual objects, it was Nicolas Poussin. He studied the antique, but he also studied nature. 'I have often admired,' says Vignuel de Marville, who knew him at a late period of his life, 'the love he had for his art. Old as he was, I frequently

Poussin was, of all painters, the most poetical. He was the painter of ideas. No one ever told a story half so well, nor so well knew what was capable of being told by the pencil. He seized on, and struck off with grace and precision, just that point of view which would be likely to catch the reader's fancy. There is a significance, a consciousness in whatever he does (sometimes a vice, but oftener a virtue) beyond any other painter. His Giants sitting on the tops of craggy mountains, as huge themselves, and playing idly on their Pan's pipes, seem to have been seated there these three thousand years, and to know the beginning and the end of their own story. An infant Bacchus or Jupiter is big with his future destiny. Even inanimate and dumb things speak a language of their own. His snakes, the messengers of fate, are inspired with human intellect. His trees grow and expand their leaves in the air, glad of the rain, proud of the sun, awake to the winds of heaven. In his *Plague of Athens*, the very buildings seem stiff with horror. His picture of the *Deluge* is, perhaps, the finest historical landscape in the world. You see a waste of waters, wide, interminable: the sun is labouring, wan and weary, up the sky; the clouds, dull

saw him among the ruins of ancient Rome, out in the Campagna, or along the banks of the Tyber, sketching a scene that had pleased him; and I often met him with his handkerchief full of stones, moss, or flowers, which he carried home, that he might copy them exactly from nature. One day I asked him how he had attained to such a degree of perfection as to have gained so high a rank among the great painters of Italy? He answered, "I HAVE NEGLECTED NOTHING." – *See his* Life *lately published*. It appears from this account that he had not fallen into a recent error, that nature puts the man of genius out. As a contrast to the foregoing description, I might mention, that I remember an old gentleman once asking Mr West in the British Gallery if he had ever been at Athens? To which the President made answer, No; nor did he feel any great desire to go; for that he thought he had as good an idea of the place from the Catalogue, as he could get by living there for any number of years. What would he have said, if anyone had told him, he could get as good an idea of the subject of one of his great works from reading the Catalogue of it, as from seeing the picture itself? Yet the answer was characteristic of the genius of the painter.

and leaden, lie like a load upon the eye, and heaven and earth seem commingling into one confused mass! His human figures are sometimes 'o'er-informed' with this kind of feeling. Their actions have too much gesticulation, and the set expression of the features borders too much on the mechanical and caricatured style. In this respect they form a contrast to Raphael's, whose figures never appear to be sitting for their pictures, or to be conscious of a spectator, or to have come from the painter's hand. In Nicolas Poussin, on the contrary, everything seems to have a distinct understanding with the artist; 'the very stones prate of their whereabouts': each object has its part and place assigned, and is in a sort of compact with the rest of the picture. It is this conscious keeping, and, as it were, *internal* design, that gives their peculiar character to the works of this artist. There was a picture of Aurora in the British Gallery a year or two ago. It was a suffusion of golden light. The Goddess wore her saffron-coloured robes, and appeared just risen from the gloomy bed of old Tithonus. Her very steeds, milk-white, were tinged with the yellow dawn. It was a personification of the morning. – Poussin succeeded better in classic than in sacred subjects. The latter are comparatively heavy, forced, full of violent contrasts of colour, of red, blue, and black, and without the true prophetic inspiration of the characters. But in his pagan allegories and fables he was quite at home. The native gravity and native levity of the Frenchman were combined with Italian scenery and an antique gusto, and gave even to his colouring an air of learned indifference. He wants, in one respect, grace, form, expression; but he has everywhere sense and meaning, perfect costume and propriety. His personages always belong to the class and time represented, and are strictly versed in the business in hand. His grotesque compositions in particu-lar, his Nymphs and Fauns, are superior (at least, as far as style is concerned) even to those of Rubens. They are taken more immediately out of fabulous history. Rubens' Satyrs and Bacchantes have a more jovial and voluptuous aspect, are more drunk with pleasure, more full of

animal spirits and riotous impulses; they laugh and bound along, 'Leaping like wanton kids in pleasant spring'[18] but those of Poussin have more of the intellectual part of the character, and seem vicious on reflection, and of set purpose. Rubens' are noble specimens of a class; Poussin's are allegorical abstractions of the same class, with bodies less pampered, but with minds more secretly depraved. The Bacchanalian groups of the Flemish painter were, however, his masterpieces in composition. Witness those prodigies of colour, character, and expression at Blenheim. In the more chaste and refined delineation of classic fable, Poussin was without a rival. Rubens, who was a match for him in the wild and picturesque, could not pretend to vie with the elegance and purity of thought in his picture of Apollo giving a poet a cup of water to drink, nor with the gracefulness of design in the figure of a nymph squeezing the juice of a bunch of grapes from her fingers (a rosy winepress) which falls into the mouth of a chubby infant below. But, above all, who shall celebrate, in terms of fit praise, his picture of the shepherds in the Vale of Tempe going out in a fine morning of the spring, and coming to a tomb with this inscription: ET EGO IN ARCADIA VIXI! The eager curiosity of some, the expression of others who start back with fear and surprise, the clear breeze playing with the branches of the shadowing trees, 'the valleys low, where the mild zephyrs use', the distant, uninterrupted, sunny prospect speak (and for ever will speak on) of ages past to ages yet to come!*

Pictures are a set of chosen images, a stream of pleasant thoughts passing through the mind. It is a luxury to have the walls of our rooms hung round with them, and no less so to have such a gallery in the mind, to con over the relics of ancient

* Poussin has repeated this subject more than once, and appears to have revelled in its witcheries. I have before alluded to it, and may again. It is hard that we should not be allowed to dwell as often as we please on what delights us, when things that are disagreeable recur so often against our will.

art bound up 'within the book and volume of the brain, unmixed (if it were possible) with baser matter!'

A life passed among pictures, in the study and the love of art, is a happy noiseless dream: or rather, it is to dream and to be awake at the same time; for it has all 'the sober certainty of waking bliss', with the romantic voluptuousness of a visionary and abstracted being. They are the bright consummate essences of things, and 'he who knows of these delights to taste and interpose them oft, is not unwise!' – The *Orion*, which I have here taken occasion to descant upon, is one of a collection of excellent pictures, as this collection is itself one of a series from the old masters, which have for some years back embrowned the walls of the British Gallery, and enriched the public eye. What hues (those of nature mellowed by time) breathe around as we enter! What forms are there, woven into the memory! What looks, which only the answering looks of the spectator can express! What intellectual stores have been yearly poured forth from the shrine of ancient art! The works are various, but the names the same – heaps of Rembrandts frowning from the darkened walls, Rubens' glad gorgeous groups, Titians more rich and rare, Claudes always exquisite, sometimes beyond compare, Guido's endless cloying sweetness, the learning of Poussin and the Caracci, and Raphael's princely magnificence crowning all. We read certain letters and syllables in the Catalogue, and at the well-known magic sound a miracle of skill and beauty starts to view. One might think that one year's prodigal display of such perfection would exhaust the labours of one man's life; but the next year, and the next to that, we find another harvest reaped and gathered in to the great garner of art, by the same immortal hands –

Old GENIUS the porter of them was;
He letteth in, he letteth out to wend.[19]

Their works seem endless as their reputation – to be many as they are complete – to multiply with the desire of the mind to

see more and more of them; as if there were a living power in the breath of Fame, and in the very names of the great heirs of glory 'there were propagation too'! It is something to have a collection of this sort to count upon once a year; to have one last, lingering look yet to come. Pictures are scattered like stray gifts through the world; and while they remain, earth has yet a little gilding left, not quite rubbed off, dishonoured, and defaced. There are plenty of standard works still to be found in this country, in the collections at Blenheim, at Burleigh, and in those belonging to Mr Angerstein, Lord Grosvenor, the Marquis of Stafford, and others, to keep up this treat to the lovers of art for many years; and it is the more desirable to reserve a privileged sanctuary of this sort, where the eye may dote, and the heart take its fill of such pictures as Poussin's *Orion*, since the Louvre is stripped of its triumphant spoils, and since he who collected it, and wore it as a rich jewel in his Iron Crown, the hunter of greatness and of glory, is himself a shade!

First published in the *London Magazine*, 1821.

On Gusto

Gusto in art is power or passion defining any object. – It is not so difficult to explain this term in what relates to expression (of which it may be said to be the highest degree) as in what relates to things without expression, to the natural appearances of objects, as mere colour or form. In one sense, however, there is hardly any object entirely devoid of expression, without some character of power belonging to it, some precise association with pleasure or pain: and it is in giving this truth of character from the truth of feeling, whether in the highest or the lowest degree, but always in the highest degree of which the subject is capable, that gusto consists.

There is a gusto in the colouring of Titian. Not only do his heads seem to think – his bodies seem to feel. This is what the Italians mean by the *morbidezza*[20] of his flesh colour. It seems sensitive and alive all over; not merely to have the look and texture of flesh, but the feeling in itself. For example, the limbs of his female figures have a luxurious softness and delicacy, which appears conscious of the pleasure of the beholder. As the objects themselves in nature would produce an impression on the sense, distinct from every other object, and having something divine in it, which the heart owns and the imagination consecrates, the objects in the picture preserve the same impression, absolute, unimpaired, stamped with all the truth of passion, the pride of the eye, and the charm of beauty. Rubens makes his flesh colour like flowers; Albano's is like ivory; Titian's is like flesh, and like nothing else. It is as different from that of other painters, as the skin is from a piece of white or red drapery thrown over it. The blood circulates here and there, the blue veins just appear, the rest is distinguished throughout only by that sort of tingling sensation to the eye, which the body feels within itself. This is gusto. – Vandyke's flesh colour, though it has great truth and purity, wants gusto. It has not

the internal character, the living principle in it. It is a smooth surface, not a warm, moving mass. It is painted without passion, with indifference. The hand only has been concerned. The impression slides off from the eye, and does not, like the tones of Titian's pencil, leave a sting behind it in the mind of the spectator. The eye does not acquire a taste or appetite for what it sees. In a word, gusto in painting is where the impression made on one sense excites by affinity those of another.

Michael Angelo's forms are full of gusto. They everywhere obtrude the sense of power upon the eye. His limbs convey an idea of muscular strength, of moral grandeur, and even of intellectual dignity: they are firm, commanding, broad, and massy, capable of executing with ease the determined purposes of the will. His faces have no other expression than his figures, conscious power and capacity. They appear only to think what they shall do, and to know that they can do it. This is what is meant by saying that his style is hard and masculine. It is the reverse of Correggio's, which is effeminate. That is, the gusto of Michael Angelo consists in expressing energy of will without proportionable sensibility, Correggio's in expressing exquisite sensibility without energy of will. In Correggio's faces as well as figures we see neither bones nor muscles, but then what a soul is there, full of sweetness and of grace – pure, playful, soft, angelical! There is sentiment enough in a hand painted by Correggio to set up a school of history painters. Whenever we look at the hands of Correggio's woman or of Raphael's we always wish to touch them.

Again, Titian's landscapes have a prodigious gusto, both in the colouring and forms. We shall never forget one that we saw many years ago in the Orleans Gallery of Actaeon hunting. It had a brown, mellow, autumnal look. The sky was the colour of stone. The winds seemed to sing through the rustling branches of the trees, and already you might hear the twanging of bows resound through the tangled mazes of the wood. Mr West, we understand, has this landscape. He will know if this description

of it is just. The landscape background of the St Peter Martyr is another well known instance of the power of this great painter to give a romantic interest and an appropriate character to the objects of his pencil, where every circumstance adds to the effect of the scene, – the bold trunks of the tall forest trees, the trailing ground plants, with that cold convent spire rising in the distance, amidst the blue sapphire mountains and the golden sky.

Rubens has a great deal of gusto in his Fauns and Satyrs, and in all that expresses motion, but in nothing else. Rembrandt has it in everything; everything in his pictures has a tangible character. If he puts a diamond in the ear of a Burgomaster's wife, it is of the first water; and his furs and stuffs are proof against a Russian winter. Raphael's gusto was only in expression; he had no idea of the character of anything but the human form. The dryness and poverty of his style in other respects is a phenomenon in the art. His trees are like sprigs of grass stuck in a book of botanical specimens. Was it that Raphael never had time to go beyond the walls of Rome? That he was always in the streets, at church, or in the bath? He was not one of the Society of Arcadians.*

Claude's landscapes, perfect as they are, want gusto. This is not easy to explain. They are perfect abstractions of the visible images of things; they speak the visible language of nature truly. They resemble a mirror or microscope. To the eye only they are more perfect than any other landscapes that ever were or will be painted; they give more of nature, as cognisable by one sense alone; but they lay an equal stress on all visible impressions; they

* Raphael not only could not paint a landscape; he could not paint people in a landscape. He could not have painted the heads or the figures, or even the dresses of the St Peter Martyr. His figures have always an indoor look , that is, a set, determined, voluntary, dramatic character, arising from their own passions, or a watchfulness of those of others, and want that wild uncertainty of expression, which is connected with the accidents of nature and the changes of the elements. He has nothing romantic about him.

do not interpret one sense by another; they do not distinguish the character of different objects as we are taught, and can only be taught, to distinguish them by their effect on the different senses. That is, his eye wanted imagination: it did not strongly sympathise with his other faculties. He saw the atmosphere, but he did not feel it. He painted the trunk of a tree or a rock in the foreground as smooth – with as complete an abstraction of the gross, tangible impression, as any other part of the picture; his trees are perfectly beautiful, but quite immovable; they have a look of enchantment. In short, his landscapes are unequalled imitations of nature, released from its subjection to the elements, – as if all objects were become a delightful fairy vision, and the eye had rarefied and refined away the other senses.

The gusto in the Greek statues is of a very singular kind. The sense of perfect form nearly occupies the whole mind, and hardly suffers it to dwell on any other feeling. It seems enough for them to be, without acting or suffering. Their forms are ideal, spiritual. Their beauty is power. By their beauty they are raised above the frailties of pain or passion; by their beauty they are deified.

The infinite quantity of dramatic invention in Shakespeare takes from his gusto. The power he delights to show is not intense, but discursive. He never insists on anything as much as he might, except a quibble. Milton has great gusto. He repeats his blow twice, grapples with and exhausts his subject. His imagination has a double relish of its objects, an inveterate attachment to the things he describes, and to the words describing them.

– Or where Chineses drive
With sails and wind their *cany* waggons *light*.[21]

Wild above rule or art, *enormous* bliss.[22]

There is a gusto in Pope's compliments, in Dryden's satires, and Prior's tales; and among prose writers, Boccaccio and Rabelais

had the most of it. We will only mention one other work which appears to us to be full of gusto, and that is the *Beggar's Opera*. If it is not, we are altogether mistaken in our notions on this delicate subject.

First published in the *Examiner*, 1816.

Notes

1. Abraham Cowley, 'To the Royal Society'.

2. See William Cowper, *The Task*.

3. Matthew 22:20.

4. 'In the nature of things' (Latin)

5. John Milton, *Paradise Lost*, v, 479–81.

6. 'Unlucky Theseus sits, and will sit for eternity': Virgil, *Aeneid*, vi, 617–8.

7. 'Evil be to him who evil thinks' (French). This is the motto of the Order of the Garter.

8. 'With a pinch of salt' (Latin).

9. Alexander Pope, *Essay on Man*, I, 218.

10. 'Things spoken for nothing' (Latin).

11. 'Rich spoils' (Latin).

12. John Dryden, *Satires of Aulus Persius Flaccus*, ii, 133.

13. John Donne, *The Second Anniversary*, 245–6.

14. James Thompson, *The Castle of Indolence*, i, 341.

15. William Shakespeare, *Antony and Cleopatra*, IV, xiv, 5–7.

16. 'It is four o'clock, citizens, we must close' (French).

17. John Keats, *Endymion*, ii, 198.

18. Edmund Spenser, *Faerie Queene*, I, vi, 14:4.

19. *Ibid*, III, vi, 31:8, 32:1.

20. Softness (Italian).

21. John Milton, *Paradise Lost*, iii, 438–9.

22. *Ibid*, v, 297.

Biographical note

William Hazlitt was born in Maidstone in 1778. The son of an Irish-born Unitarian minister who sympathised with the American Revolution, Hazlitt spent his childhood in Ireland and New England before moving to the village of Wem in Shropshire. He then attended the New Unitarian College in Hackney, London, but refused to enter the ministry, hoping instead to pursue a career as a philosopher or painter.

Hazlitt alternated between writing and painting, but having been introduced to the likes of Coleridge, Wordsworth and Charles Lamb, he eventually turned away from painting as a career. His first books were political studies: *An Essay on the Principles of Human Action* (1805) was followed by a response to a piece by Thomas Malthus, *A Reply to the Essay on Population* (1807) and *The Eloquence of the British Senate* (1807).

In 1808 he married Sarah Stoddart and settled in Salisbury before moving to London four years later. Here he began a career as a public lecturer, politician, journalist and arts critic. Among others, he wrote for the *Morning Chronicle* and for Leigh Hunt's *Examiner*, and in 1817 he published *Characters of Shakespear's Plays* and a collection of essays, *The Round Table*. Meanwhile he continued to lecture and write theatre reviews and published further books including *Political Essays* (1819) and *Table Talk* (1821–2).

In 1822 he divorced his wife in the false hope of marrying his landlord's daughter, Sarah Walker, with whom he had become infatuated. His account of this, *Liber Amoris* (1823) harmed his reputation, but he went on to take another wife, Isabella Bridgewater, and then produced two of his best-known works: *The Spirit of the Age* (1825) and *The Plain Speaker* (1826). William Hazlitt died in Soho and is buried in St Anne's churchyard.

SELECTED TITLES FROM HESPERUS PRESS

'on'

Author	Title	Foreword writer
John Donne	*On Death*	Edward Docx
John Stuart Mill	*On the Subjection of Women*	Fay Weldon

Classics, Modern Voices and Brief Lives

Author	Title	Foreword writer
Cyrano de Bergerac	*Journey to the Moon*	Andrew Smith
Richard Canning	*Brief Lives: Wilde*	
Joseph Conrad	*Heart of Darkness*	A.N. Wilson
Charles Dickens	*Doctor Marigold's Prescriptions*	Gwyneth Lewis
Annie Dillard	*The Maytrees*	
Beppe Fenoglio	*A Private Affair*	Paul Bailey
Yasmine Ghata	*The Calligraphers' Night*	
Johann Wolfgang von Goethe	*The Man of Fifty*	A.S. Byatt
Mikhail Kuzmin	*Wings*	Paul Bailey
Mikhail Lermontov	*A Hero of Our Time*	Doris Lessing
Carlo Levi	*Essays on India*	Anita Desai
Klaus Mann	*Alexander*	Jean Cocteau
Patrick Miles	*Brief Lives: Chekhov*	
Henry Miller	*Aller Retour New York*	
Luigi Pirandello	*The Turn*	
Marquis de Sade	*Betrayal*	John Burnside
Sándor Petőfi	*John the Valiant*	George Szirtes
Leo Tolstoy	*Hadji Murat*	Colm Tóibín